IMAGES
of America

MANSFIELD

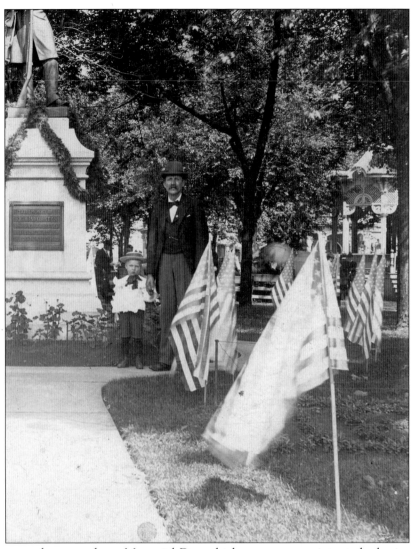

This photograph was made on Memorial Day, which seems appropriate at the beginning of a book of history, as that has always been the day for looking back and remembering. When this picture was taken, people still called the holiday Decoration Day, when the graves of veterans were marked with flags and flowers, and on that day in 1913, when the town was a little over a century old, there were fewer than 600 graves of veterans in the Mansfield cemetery to decorate. As Mansfield marks its 200th birthday, there are now more than 6,000 veteran graves in those same shady glens that are covered with flags, testament, certainly, to each veteran's devotion to the greater good but also to the town's commitment to holding that sacrifice in honor through its collective memory and commemoration. (Mark Hertzler collection.)

On the cover: The bandstand in Central Park on the square in Mansfield, photographed in 1908 on the town's centennial anniversary, witnessed more than 80 years of all the things that went on in the heart of town. After it was taken down in the 1950s, having gone to pieces due to weather and termites, it took another 40 years, but the city finally built a new public stage to stand in the square and witness the good times and bad that pass through the town: this time made of steel. (Phil Stoodt collection.)

IMAGES
of America

MANSFIELD

Timothy Brian McKee

ARCADIA
PUBLISHING

Published by Arcadia Publishing
Charleston SC, Chicago IL, Portsmouth NH, San Francisco CA

Printed in the United States of America

Library of Congress Catalog Card Number: 2007927175

For all general information contact Arcadia Publishing at:
Telephone 843-853-2070
Fax 843-853-0044
E-mail sales@arcadiapublishing.com
For customer service and orders:
Toll-Free 1-888-313-2665

Visit us on the Internet at www.arcadiapublishing.com

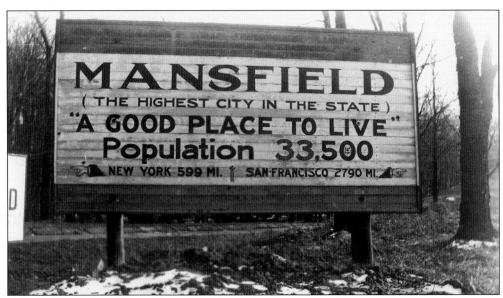

This sign on the Lincoln Highway entering Mansfield was photographed in 1926 by Georg Nilsson, who had just moved to America from Sweden. He was so proud of his new hometown that he took pictures all over Mansfield to send to his family, showing them what the place he loved looked like. In time and decades, his name was Americanized to Nelson, and when his daughter, born in Mansfield, traveled to Sweden in 2000 to see the old homeland, these pictures were presented to her to come back to Mansfield. (Anna Marie Nelson McCracken collection.)

CONTENTS

This book is assembled on the occasion of Mansfield's 200th birthday. Many of the stories and facts contained herein were thoughtfully noted and passed down to this generation by historians from the last couple centuries, and some were gleaned from sources other than those published. In order for those 100 years from now, who are endeavoring to fit Mansfield into the perspective of their epoch of American history, to have an accurate portrait of this generation at year 200, here are provided a few salient facts. As of 2008, the population of Mansfield is around 50,313; the area of the city encompasses a grid roughly 10 miles north to south and 5 miles east to west; the median household income is $30,176; the ethnic diversity is calculated at approximately 76 percent white, 20 percent black, 0.7 percent Asian, 0.3 percent Native American, and 3 percent other, including 1.3 percent Hispanic/Latino; in 20,182 households of which 40.5 percent are married couples, the average family size is 2.93; and the median age is 36 years. (Author's collection.)

INTRODUCTION

Mansfield began as a little town laid out around a public square in the vast Ohio forests inhabited by wild animals and Wyandots. It was staked out by a group of surveyors who named the place after their boss in Washington who never set foot anywhere near the town that bore his name. Beset almost immediately with peril from wartime threats, the town gained its first identity as a safe haven in the wilderness when two blockhouses were built on the square for settlers to come together in common protection. From this original gathering, the heart of the community was born—as a place where people can feel safe, a place to gather the family, a home.

This is a hometown. A lot of people are from Mansfield. No matter where in the world they may have gone off to, they were raised here. This is the town's chief identity—as a good place to raise a family—and that is the essence of hometown.

From its humble beginnings there was no reason to think that Mansfield would ever amount to much. It had the requisite number of frontier scoundrels, drunks, and oddballs, including a curious barefoot preacher of sorts who planted nurseries of apple trees wherever there was an open glade in the forest. But something about this place drew together men of vision who could see past the forest to a time when the town's placement in the heart of America would provide an opportunity to take a role in the country's growth. So they brought the railroads here, and the rails brought industries, and the jobs brought people, and the people brought ideas that made the industries flourish.

There was a time, and more than once, when Mansfield led the nation with innovative ideas in aspects of life as divergent as stoves, streetcars, and steel to the Safety Town program. It is still happening today—in fields of networking and service technology—that the town pioneers techniques and systems that become the standard in American life.

Having lived through so many different eras of American history, Mansfield has changed again and again in the light of each new decade of challenges, opportunities, and trends. Facing new unknown futures over and over, it has adapted a new face in every generation that reflects national styles and tastes, yet ever maintaining the unique qualities and charms inherent in its essential identity.

This book does not purport to be a history of Mansfield; it is a portrait. The town is an assemblage of very different worlds that do not often intersect, in neighborhoods so different it is hard to believe that they could all be in the same town. These pictures show what all of the diverse cultures share in common, for following those different limbs toward the ground they all join in one trunk. The common ground that exists is in the past. These photographs constitute a collective memory, and this is a Mansfield family album.

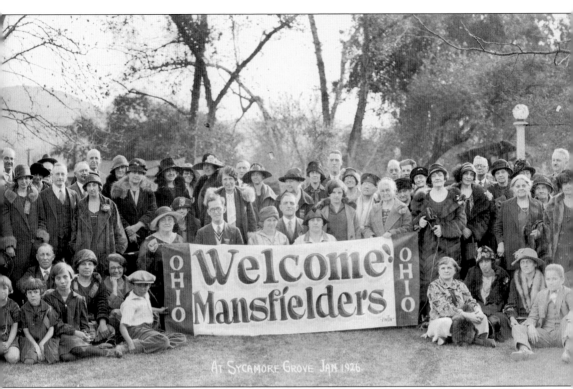

AT SYCAMORE GROVE JAN 1926.

There are former Mansfielders all over the country and all over the world, but in some places there are so many in one area that little Mansfield clubs find spontaneous life far from home. A couple towns in Florida had them in the 1940s and the 1960s when so many folks retired down there from here, and when those generations passed on, a couple new groups showed up in other locations. The hometown reunion photographed here took place in 1926. (Mark Hertzler collection.)

One

WHAT MANSFIELD IS KNOWN FOR

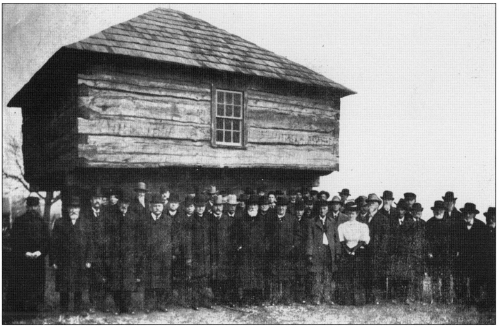

The blockhouse became a symbol of Mansfield's heritage in 1908 on the occasion of the town's 100th birthday celebration. Built originally for defense during the War of 1812 on the public square when Mansfield was a frontier outpost in the wilderness, the structure served as the town's first courthouse and jail until 1816 when it was removed to East Second Street and covered with barn siding for its preservation. When it was brought back to the square for the centennial celebration, it was repaired with hewn beams from a pioneer cabin and displayed on the courthouse lawn until after the commemorative year, when it was removed to its present location in South Park. (Mansfield/Richland County Public Library collection.)

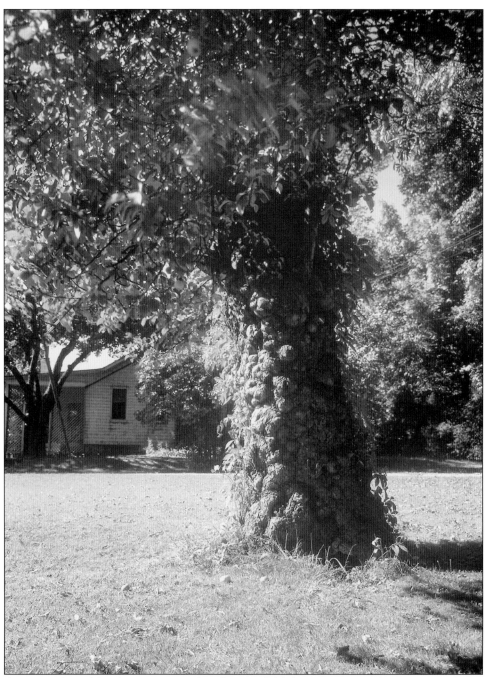

Johnny Appleseed has been associated with Mansfield during its entire history, since he was here even before the town was. Long celebrated in American folklore as a frontier saint planting orchards in the wilderness, the actual man, John Chapman, called Richland County his home and base of operations for nearly half his life. When photographer Andreas Feininger created a photo essay in 1945 on American legends for *Life* magazine, he found his image for Johnny Appleseed in this ancient apple tree on Woodland Road, one of the last to survive from Chapman's nurseries. (Getty Images.)

The legend of John Chapman was given national status by a *Harper's Weekly* magazine article in 1871 that transformed local Mansfield gossip and hometown stories into the epic adventures of American myth by which Chapman attained the status of national hero. A monument in his memory was erected in 1900 at Middle Park that was later recarved in marble and placed in South Park where it stands today near the blockhouse. The 120-year-old tree that appeared in *Life* magazine finally fell in a 1959 windstorm and was cut into souvenir firewood by another Mansfield personality, Hugh Fokner, whose reputation for eccentric lifestyle was not unlike that of John Chapman himself. (Right, Phil Stoodt collection; below, author's collection.)

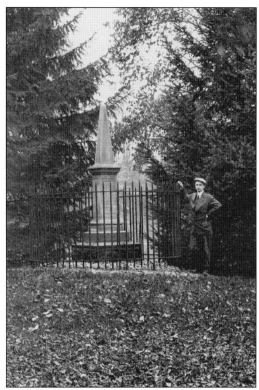

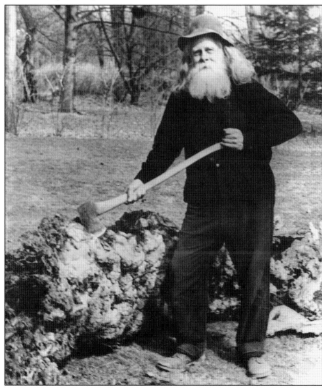

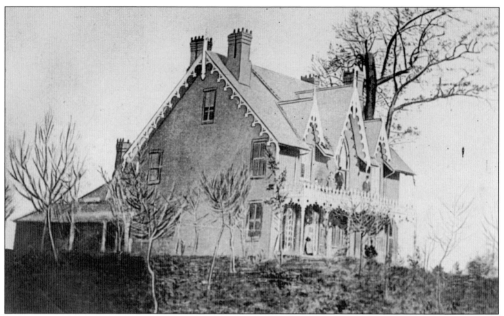

Oak Hill Cottage was built in 1847 by local entrepreneur James R. Robinson on a hill overlooking tracks of the Mansfield, Sandusky and Newark Railroad, which made him one of his many fortunes. He left Mansfield to build many more, fortunes that is, including one or two from Mexican silver mines. When he died in 1892, he was said to be the richest man in Maryland. (Pamela White collection.)

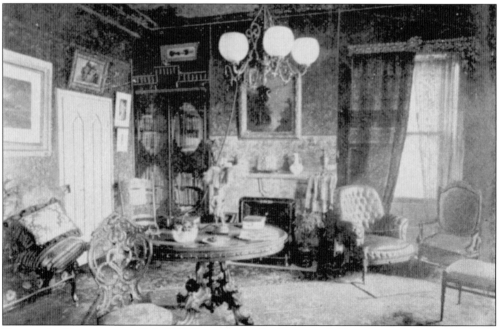

During the Victorian era, Oak Hill Cottage was the home and showplace of the Dr. Johannes Jones family. An itinerate physician known around the United States for his patent medicine Peruna, Jones was well traveled and filled his home with ornate furnishings from all over the world. (Mansfield/Richland County Public Library collection.)

A relative of the Jones family, author Louis Bromfield, brought Oak Hill literary immortality through his best-selling 1924 novel *The Green Bay Tree*, which fictionalized the house as "Shane's Castle." His memories of spending time at Oak Hill provided the grand setting for his story of the conflicting values of industrialization in Mansfield, which he referred to in his book simply as "the Town." (Mansfield/Richland County Public Library collection.)

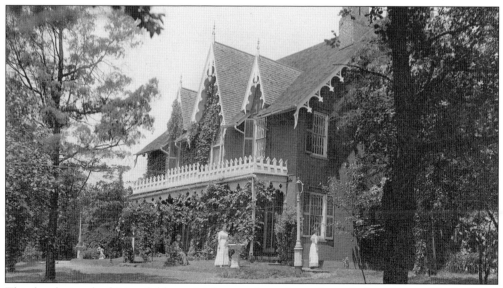

This lovely jewel of Mansfield survived to modern times through the efforts of Leile Jones, the last member of the family to live in Oak Hill Cottage. In 1965, it passed to the care of the Richland County Historical Society, which spent 20 years in restoration before opening it to the public, renewed to its Victorian splendor. (Richland County Historical Society collection.)

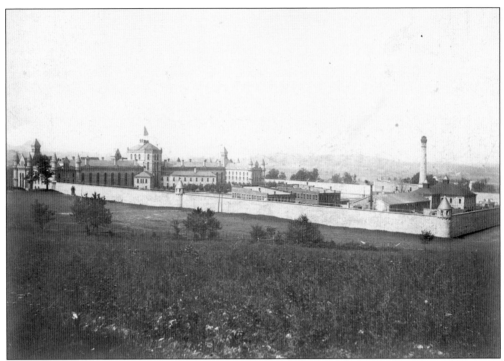

The Ohio State Reformatory opened in 1896 with 150 inmates who went to work to complete the place, erecting a 25-foot stone wall surrounding the 15-acre complex. Heralded as the best and most model prison of its kind when it opened, by 1937 its overcrowded conditions were called disgraceful. (Richland County chapter, Ohio Genealogical Society collection.)

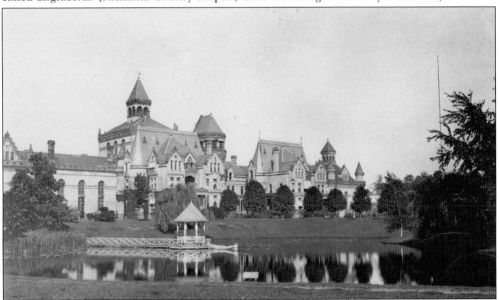

The Ohio State Reformatory was designed by Cleveland architect Levi Scofield, most noted today for having designed the massive soldiers and sailors monument in the public square of Cleveland. His design was to be reminiscent of the old world castles of Germany to reflect the age and solidity of law and order and civilization. (Marge Graham collection.)

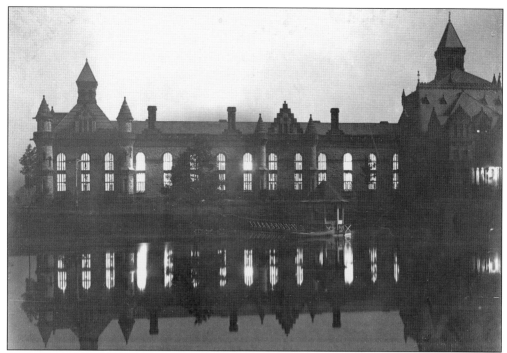

The Ohio State Reformatory was a city within a city that was largely self-sufficient through many of the years. By the 40th year of its operation, over 32,000 prisoners had passed through its walls, and by the time it closed in 1990, that number was easily more than 100,000. It is difficult to gauge how much the prison has shaped the nature of Mansfield, what with prisoners' families residing here during and after incarceration, but to this day with Mansfield's new prisons, the population figures of the town are given with and without prisoners. (Richland County chapter, Ohio Genealogical Society collection.)

This reformatory baseball team from the 1930s is made up of prison guards and offers a new slant to the traditional pinstripe baseball uniform with its own brand of prison stripes. (Mark Hertzler collection.)

Kingwood Center was built in 1926 as the home of Charles Kelly King. He came to Mansfield in 1893 to engineer the development of the Ohio Brass Company into an innovative leader in the industry of streetcars and electrical power utilities, becoming president of the company by 1928 and eventually chairman of the board. Bequeathed to the City of Mansfield upon King's death in 1952, Kingwood became widely recognized for its extensive formal and landscape gardens when the pool and tennis courts were converted to flower beds and the greenhouses developed for horticultural research. Although he lived in grandeur and entertained opulently, King was known to be an unpretentious and upright gentleman who preferred to walk to work, his chauffeur following discreetly several blocks behind until he was ready to ride. (Author's collection.)

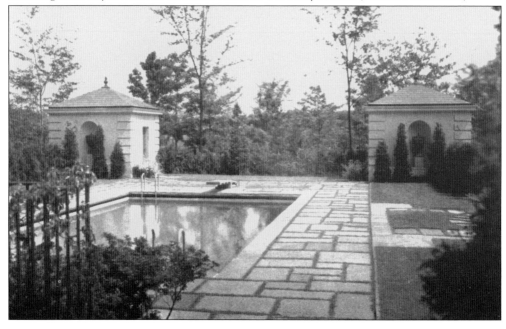

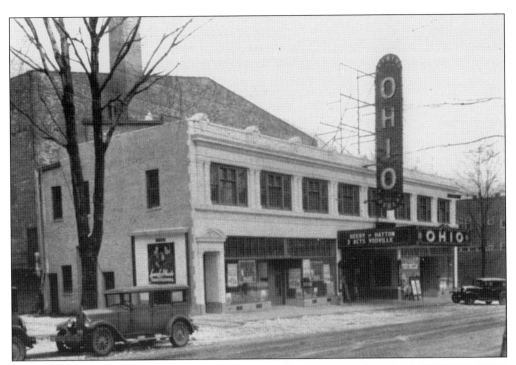

The Renaissance Theater, which has been the home of the Miss Ohio Pageant every June since 1981, began its life as a movie house called the Ohio Theater. When it opened in 1928, it was only one of seven movie houses in downtown Mansfield, but very shortly three of them closed because the Ohio was everybody's favorite with its plush interior and top-rate films. In the early days, there was live entertainment between reels, including Josephine Cook, a Mansfield girl who whistled professionally, having been to college for whistling. During the decline of downtown in the 1970s, the Ohio eked out a living showing pornographic films and looked headed for demolition until it was given a second life and reborn as the Renaissance Theater, named for the cultural renewal it brought and its intact baroque decor. The young woman in the ticket window is the author's mother in 1944, pretending she's 16 like she told her boss in order to get the job. (Above, Mansfield/Richland County Public Library collection; right, Jeannine McKee collection.)

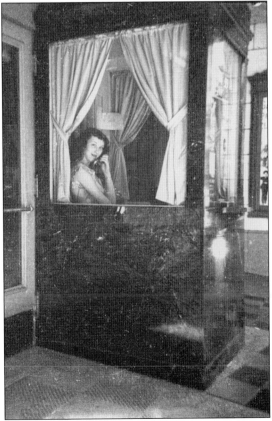

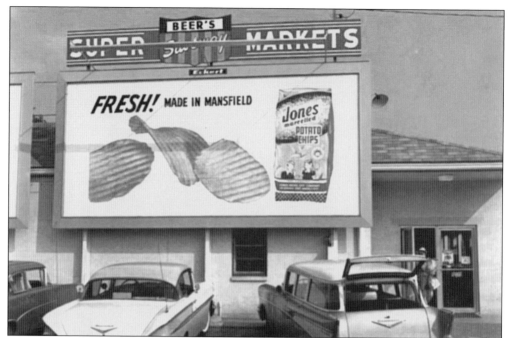

Jones Potato Chips have been made in Mansfield since 1945, and they are such an integral part of life here that when people move away from town and try everyone else's chips they come to recognize just how good they had it here and never even knew it. This is why the Jones Company ships its chips all over the world to former Mansfielders. (Bob Jones collection.)

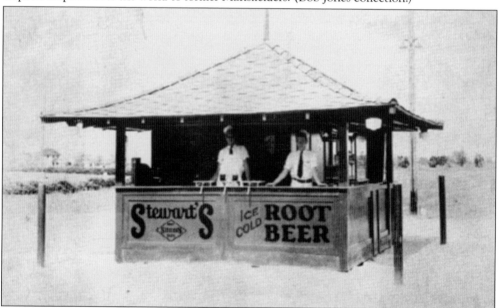

Stewart's Root Beer, sold around the world today, had its beginnings in Mansfield when Frank Stewart, a city schoolteacher, decided to augment his summer salary in 1924 by selling root beer at a drive-in stand on Ashland Road near the underpass. His special recipe caught on, and by the 1960s, there were more than 60 Stewart's Root Beer stands in six states selling frosty glass mugs on trays that balanced on a car's open window. (Cadbury Schweppes Americas collection.)

The Mansfield Art Center enjoys exhibitions, classes, and events in a charming and modernistic setting today, but it was not always so secure for local artists. After World War II, a small group of painters began setting up their easels in different places around town to paint together, and in 1945, they exhibited their first May show. Incorporating as the Mansfield Fine Arts Guild, their annual show was held wherever they could find space—in the library, at the Leland Hotel, or at Kingwood—and in the fall they sold their works at the art fair on the square. The organization finally found a permanent home in 1971 when the Mansfield Art Center opened. (Mansfield Art Center collection.)

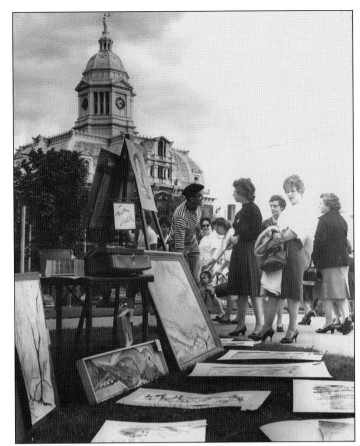

Snow Trails has made the prospect of long winters in Mansfield's snowbelt region far more appealing since it opened in 1961 as Ohio's first ski resort. Starting with this simple barn that became the first ski lodge and a north-facing slope that is the last to melt off every spring, Snow Trails has grown to a small Alpine village known to many thousands of skiers all over Ohio. This view from the top of Mount Mansfield shows the Possum Run Valley, known for the coldest temperatures in the state—usually 5 to 10 degrees colder than at the Mansfield airport. (Dave Carto collection.)

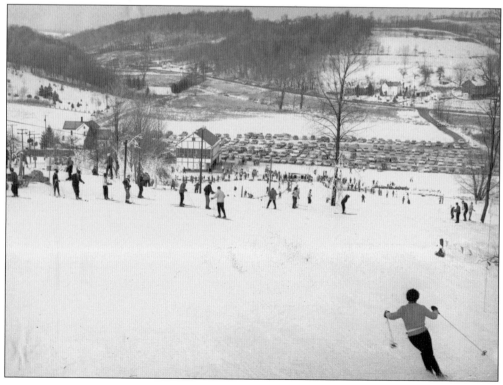

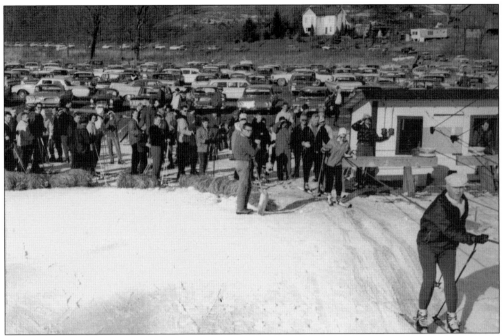

Back before Snow Trails had the series of massive ski lifts seen there today, it all began with two simple motorized rope tows, one for advanced skiers and one for beginners. A U.S. pioneer in the science of manufacturing artificial snow, Mansfield's ski resort draws water for the snowblowers from two small lakes on the valley floor. The snow guns can cover over six acres of slope with three to four inches of man-made snow in 24 hours when the temperatures are below 25 degrees. (Above, Dave Carto collection; below, Jeff Sprang photograph.)

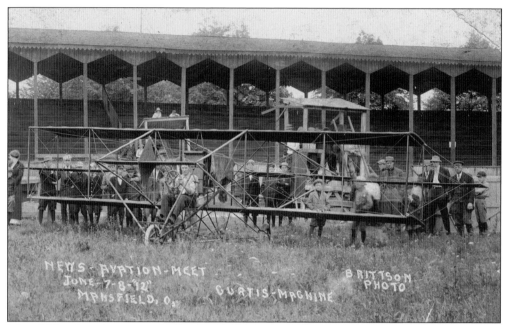

Mansfield Lahm Airport and the 179th Airlift Wing of the Ohio Air National Guard are evidence today of Mansfield's long association with flight. Frank Lahm, who grew up on Third Street, was issued the second aviation license in America and was the very first passenger ever in a plane with the Wright brothers. The air show photographed here at the fairgrounds on Springmill Street took place in 1912, only eight years after the first airplane got off the ground. (Phil Stoodt collection.)

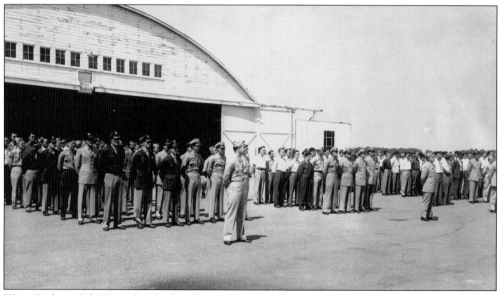

The 179th Airlift Wing has had different names and designations through the years, but its Ohio Air National Guard base goes back to 1948 when, eager to respond to a federal request for manpower, 145 men were recruited in three days to form the first Mansfield unit, then called the 164th Fighter Squadron. Here they are in front of hangar No. 7, their first home at Mansfield Municipal Airport. (179th Airlift Wing archives.)

The airport was born in 1928 as a landing field in a pasture that was tiled and marked with flags. A few hangars were added in the 1930s, but the place really took off in the 1940s when the federal government designated Mansfield as a site to move war materials. Dedicated in 1946 as Mansfield Municipal Airport, it saw Trans World Airlines flights for a few years and commuter airlines in more recent memory. Rededicated as Mansfield Lahm Airport in the 1960s, the runways are the highest in the state and long enough to land the biggest aircraft in the world. A familiar sight in the skies over town is the C-130H Hercules cargo planes that have lived here since 1991. This airplane, photographed over the city, is named *Spirit of Mansfield*. (179th Airlift Wing archives.)

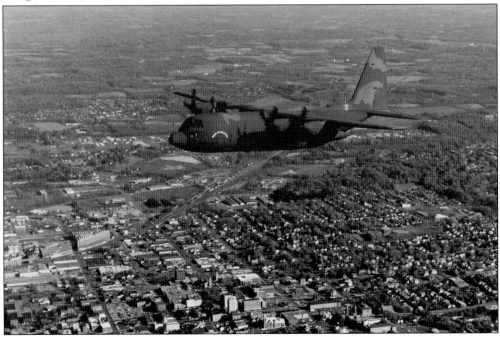

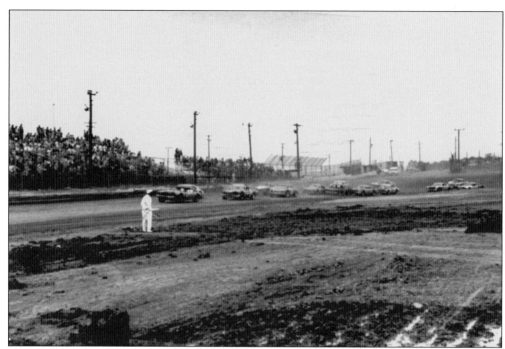

Mansfield Motor Sports Speedway began back in the late 1950s as a humble dirt track that was dedicated as Mansfield Raceway in 1960 when the bleachers were built and this photograph was taken. It was a collection of eclectic vehicles that raced there back then, all homemade and innovative including a sprint car made from a war surplus glider plane. The car on the left pictured below actually entered this world as a 1935 Buick, before it was split down the middle and side to side and then welded back together into a "straight eight" that raced in 1959. (Joe and Shirley Thompson Jr. collection.)

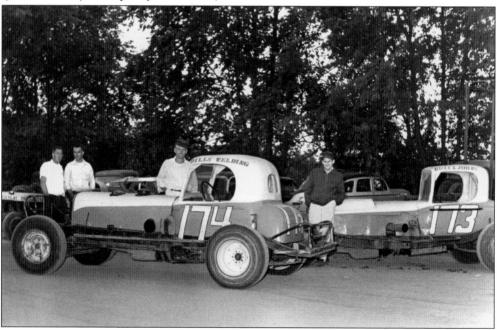

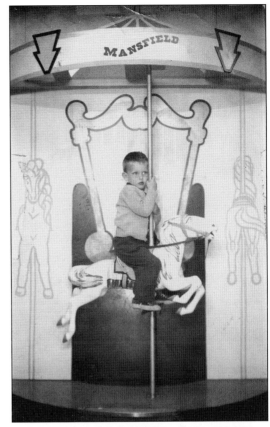

The carousel, which has played such an integral role in the revitalization of downtown Mansfield, was clearly anticipated many years before its construction by this studio portrait taken downtown in the 1940s. There was also a summer merry-go-round at Luna Park next to North Lake back in the early part of the last century, but it was destroyed in 1934 by fire. There have been numerous carousel rides that have made the rounds at fairs and festivals in town throughout the ensuing decades, but it was not until 1991 when Richland Carrousel Park opened downtown that Mansfield became known around the country as a carousel center and the first city since the 1930s to build an authentic all-wooden ride. (Author's collection.)

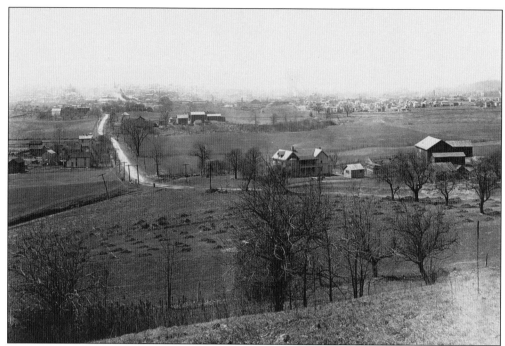

These two photographs were both taken from the top of Ashland Hill looking toward downtown Mansfield. The only difference between these two pictures is 100 years, the development of the telephoto lens, a population increase of 35,000 people, approximately one degree of global warming, the complete extinction of the passenger pigeon, and the proliferation of the American crow, which, if one squints closely enough, can probably be seen eyeing the sidewalks of downtown with criminal intent. (Above, Bob Carter collection; below, Jeff Sprang photograph.)

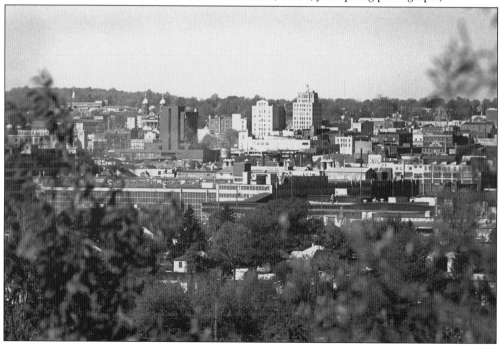

Two

MAIN STREET

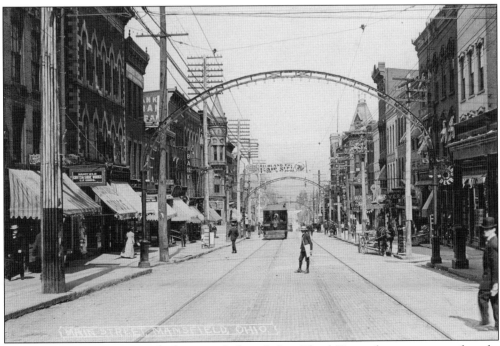

This picture of Main Street looking north from below Third Street shows two sets of tracks embedded in the brick pavement. Streetcars traversed the hill for 50 years from the 1880s to the 1930s, and back then traffic moved in both directions up and down the hill. The one-way traffic grid in downtown was not implemented until the 1960s. (Phil Stoodt collection.)

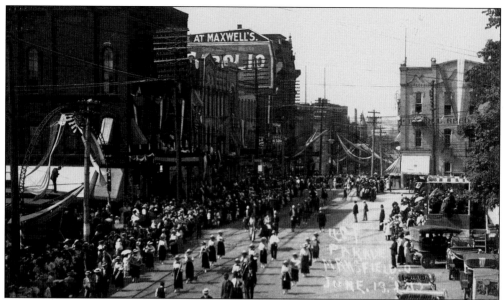

The tallest building in the photograph above is Maxwell's, a landmark built in 1869 as an opera house, whose upper floor housed a stage and auditorium where touring troupes, minstrel shows, and comedy acts performed for half a century. Throughout the years, the street-level storefront housed a bookstore, attorneys' offices, and finally the retail establishment known for generations as Maxwell's. An early fire took off the upper story before the 1940s, and a second fire in 1969 made way for the first parking lot on Main Street. (Phil Stoodt collection.)

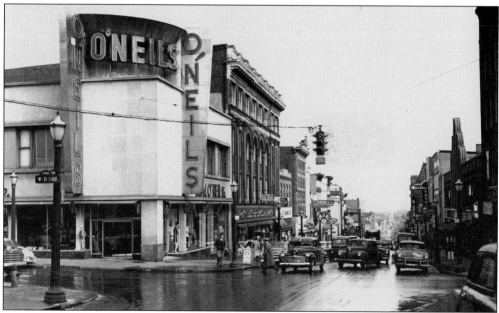

Anticipation ran high for the opening of O'Neils in time for Christmas shopping in 1946, and workmen were scheduled around the clock for weeks to be ready to open the doors for a crowd expected to be no less than 10,000 people. Fifty thousand actually showed up at the grand opening, and one has to wonder where they all parked. O'Neils moved out of downtown in the late 1960s when the mall was built. (Richland County chapter, Ohio Genealogical Society collection.)

The Biddle Building on Third Street got a new coat of white paint in 1939, and attorney George Biddle had the workmen paint the mortar black between the bricks, which, from across the street, gave it the appearance of something out of the funny pages, so the fellows at the bank called it the "Mickey Mouse Building." When young George Biddle was home from art school, he climbed up on the fire escape railing and made it official. The picture has survived to this day because it was painted with roofing tar. (Jeff Sprang photograph.)

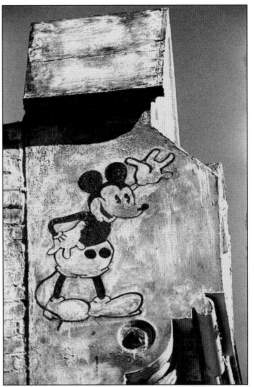

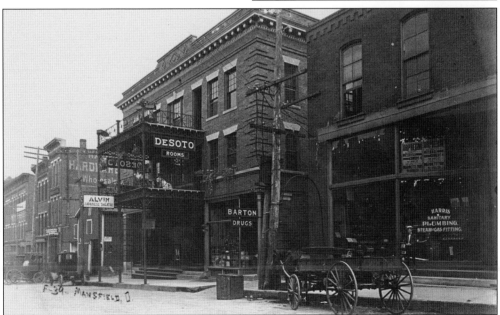

The DeSoto Hotel was built in 1909 on the south side of Third Street east of Main Street, the last of the old-time hotels built in downtown. It served as a marquee for the Alvin Theater for a couple decades and then suffered when the Leland Hotel and other large hotels on main thoroughfares made Third Street far less traveled. It was destroyed in 1965 by a dramatic and deadly fire. (Phil Stoodt collection.)

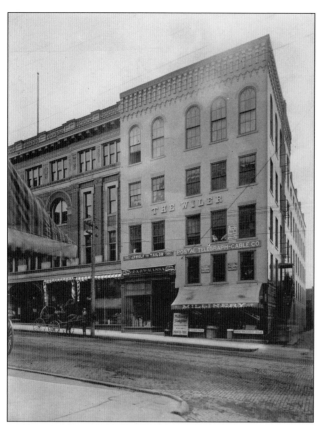

Mansfield was nicknamed "Little Chicago" in the decades surrounding World War II because it was what was called a "wide open town" where the railroad depot was within walking distance of 47 saloons and a stroll up to the business blocks went through a brothel district. There were a dozen hotels downtown of all variety, but the oldest and most storied of them all was the Wiler House that dated back to the 1820s. It sat next to the Bird Building, a complex of 28 offices variously occupied throughout the years with more and less colorful business folk ranging from, among others, a magician, a wrestling promoter, the requisite law firms and bookie joints, and a dance studio at the top of the stairs. (Left, Richland County chapter, Ohio Genealogical Society collection; below, Phil Stoodt collection.)

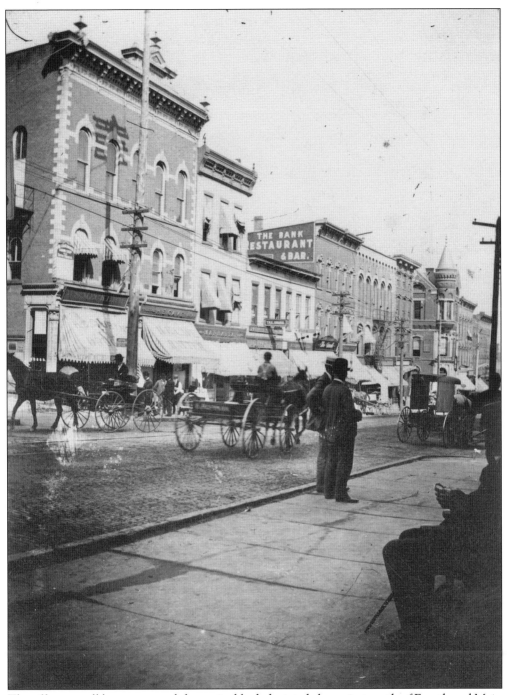

The offices are all long gone, and the entire block depicted above, just south of Fourth and Main Streets, is the Richland Carrousel Park today. (Mark Hertzler collection.)

The two photographs facing each other across these two pages are two corners of Main Street that faced each other across Fourth Street, which was, starting in 1915, the downtown stretch of the Lincoln Highway—the first improved road for automobiles running from coast to coast. Easily the busiest street in town once car travel flourished, it was from this intersection that the Lincoln Highway guidebook measured the distance from Mansfield to New York and San Francisco. (Engwiller Properties collection.)

Back when the Lincoln Highway was America's main street, all manner of *Lincoln* places appeared along the route, including Lincoln Heights east of town and the Lincoln Restaurant on Fourth Street. In the ensuing years, this place has always been a restaurant; starting in the 1950s it was the Daily Bar, and it more lately incarnated as the Wooden Pony and Brandt's Bistro. (Richland County chapter, Ohio Genealogical Society collection.)

North Main Street has always been where one goes to get Coney dogs, and during the war, it had only war-issue hot dogs that were thin and not very long, so a real Coney from those days was loaded extra high to fill up the bun. All the buildings depicted here, the southeast corner of Fourth and Main Streets, are entirely vanished today under the municipal parking lot. (Engwiller Properties collection.)

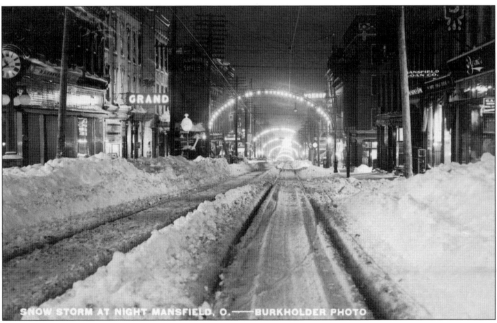

This photograph of the arch lights on Main Street, seen here in all their splendor, had to have been taken between 1908 and 1919 because that is how long they lit up the town. In a burst of civic enthusiasm, they were placed over every major intersection downtown to usher in the modern era during Mansfield's centennial year, but by the time World War I had ended, they looked old-fashioned and outdated and were quietly snuffed out. (Phil Stoodt collection.)

The Brunswick was originally conceived as an office building when it was built in 1879, but the city had more need for hotel rooms, so it stood for 85 years at the corner of Fourth and Diamond Streets as the Brunswick Hotel. It had a large billiard room off the lobby that was Mansfield's first movie theater, called the Arbor. It existed so early in the days of motion pictures that the projectionist had to be reprimanded for cranking the machine too rapidly when the movie got exciting. (Eileen Wolford photograph.)

Kirschbaum's Restaurant on Main Street credited itself with the first plate lunch in Ohio after importing the idea from Boston. It had a 15¢ plate lunch plus 5¢ for pie. When the Kirschbaums closed the restaurant in 1923 to focus exclusively on candy making, Lillian Kirschbaum was quoted as saying, "We were feeding between 800 and 900 people a day. The greatest number of people we ever fed was 1,729 in 2 hours when Ringling's Circus was in the city." (Mansfield/Richland County Public Library collection.)

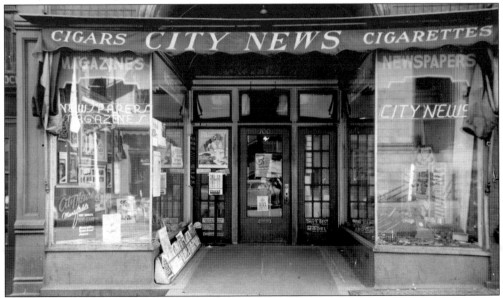

City News has been on Main Street since 1939 when it was established by one of the Saprano brothers. Another brother had Saprano's Bar across the street and another ran Saprano's Cigars down the block. First-generation Americans, the brothers would sweep out their father's delivery truck and all pile in to run up to Cedar Point to dance all night. Their classmates said that they were the ones who had all the fun in town. (Sue Saprano collection.)

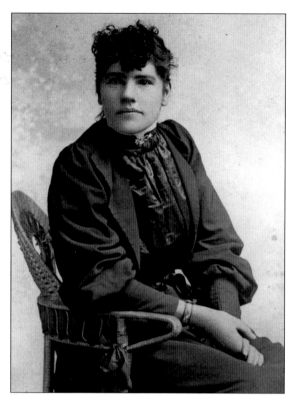

Walking on Main Street in the early 1900s, one would be likely to encounter a sight so singular it might seem to have come out of a book or a movie, and in fact it did just that. She was a woman who came into town dressed in the high-shouldered, bustled gowns, broad flower-strewn hats, and lacy mitts of the Victorian era long after those fashions had passed to another century. Her name was Phoebe Wise, and aside from her other more obvious eccentricities, it was well known that she had shot the man who doted on her too closely, giving her an aura and respect that was legend locally. When author Louis Bromfield wrote of her in his novels and short stories her legend spread around the world in 26 languages, culminating in the early 1950s when one of his tales of her was filmed with Lilian Gish portraying her on national television. (Left, Richland County chapter, Ohio Genealogical Society collection; below, Malabar Farm State Park collection.)

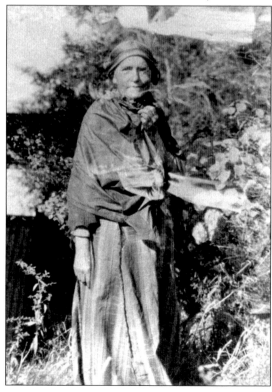

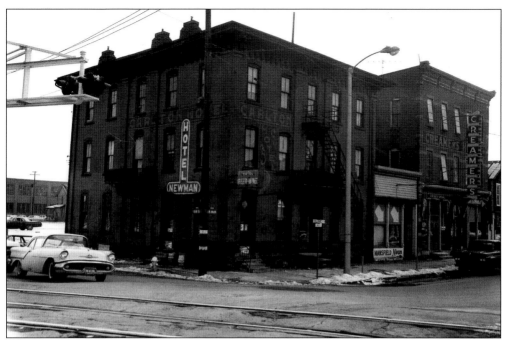

The hotel in this photograph (above), which stood by the tracks on North Main Street first as the Carlton and then as the Newman, has been gone for over 40 years. The hotel next to it, however, survived until more recent memory as Creamers, a family grill famous for its goulash since 1921. Before it was Creamers it was the Newton Hotel that catered to traveling salesmen, being so close to the Union Station. It is seen in the picture below taken during the flood of 1913. (Above, Eileen Wolford photograph; below, Phil Stoodt collection.)

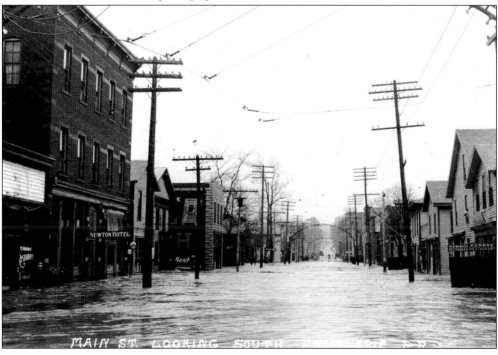

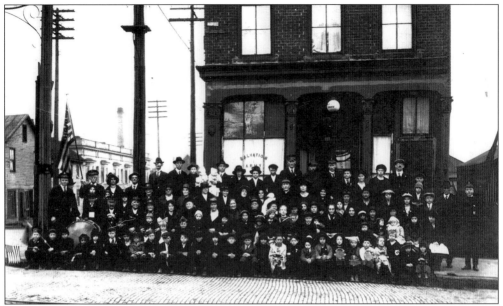

The Salvation Army came to town in 1888 and opened its doors at an empty roller rink on North Main Street. Moving around through the decades to many addresses on the north side of town, it finally found a home on South Main where it still resides today. Its original accommodations, pictured above, were replaced in 1922 by a more modern facility, which was in turn replaced in 1978 by the center found there now. (Salvation Army collection.)

The Friendly House began originally on North Main Street next to the tracks as the People's Mission in 1898. It hung up its more welcoming name in 1912 and offered the town's first free playground, kindergarten, and baby clinic in the 1920s. It was the first to teach English as a second language under the care of the Gimbles, who were the welcome wagon for Mansfield's new immigrants for many years. The Friendly House on North Mulberry Street opened in 1949. (Friendly House collection.)

Three

THE SQUARE

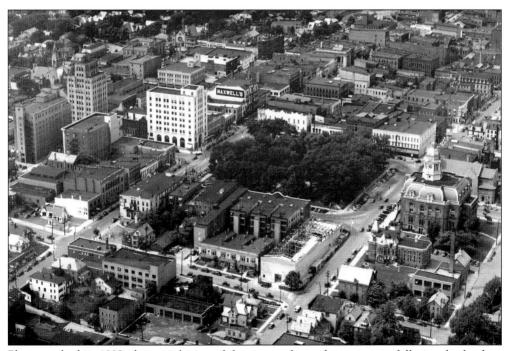

Photographed in 1939, this aerial view of the square shows downtown in full vigor back when one had to drive around Central Park to get from one end of Park Avenue to the other and then drive around block after block hunting for a parking place. (Jeff Wahl collection.)

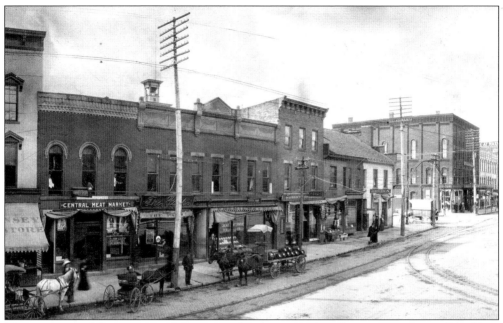

This rare view of the west side of the square shows a time when three stories was a tall building downtown. The oldest block to survive to the present, these different storefronts have housed dozens of various shops, pharmacies, diners, wholesale houses and retail markets, groceries, emporiums, and newsstands throughout the last couple hundred years. (Mark Hertzler collection.)

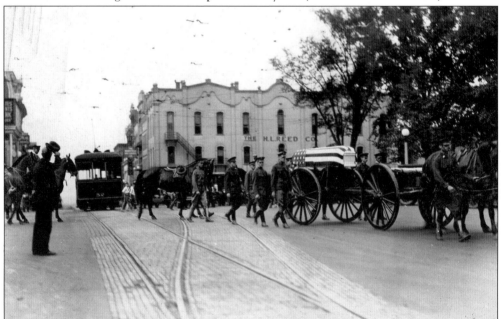

This military caisson passes in front of Reeds like the slow procession of years that building has seen. The oldest site on the square, it is where Mansfield's first store stood in a clearing back when all of town was still a great forest. A familiar sight for generations, the graceful facade was built at the end of the Civil War and, except for acquiring and shedding countless layers of paint, remains unchanged through time. (Engwiller Properties collection.)

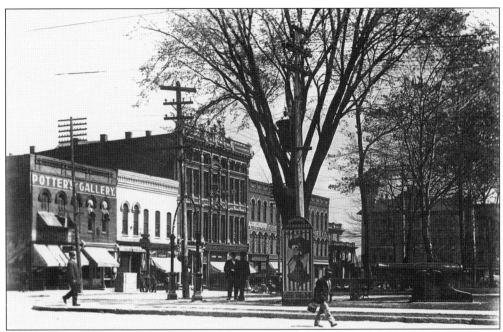

The north side of the square has been erased and reconfigured at least once since the beginning. The two buildings closest to Diamond Street in the right side of these views, Quality Furniture and the Newman building, both burned in 1944 and rose again from the ashes as Sears and Woolworth's. At the left of the picture above is the photography studio of the Potter brothers whose early stereopticon views of Mansfield document much of the town's early history from when the art of taking pictures was still new. The photograph on page 44 showing two courthouses was taken from the roof of the Potters' gallery. (Above, Phil Stoodt collection; below, Richland County chapter, Ohio Genealogical Society collection.)

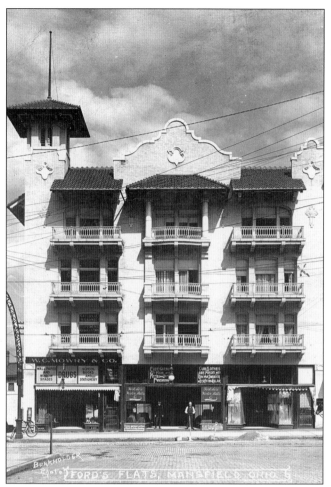

The Ford Flats apartment building stood on Diamond Street where the fountains are today in the courtyard of the municipal building. It was built by the family best known today for the S. N. and Ada Ford Foundation. The Fairview Hotel, at the corner of Diamond and Third Streets, was built as an apartment building also but converted to a hotel because of the traffic of travelers on the interurban streetcar lines whose depot was right across the street. As streetcar and railroad traffic faded in the 20th century, downtown hotels did also, and the Fairview made way for Mansfield's first parking garage. (Left, Phil Stoodt collection; below, Richland County chapter, Ohio Genealogical Society collection.)

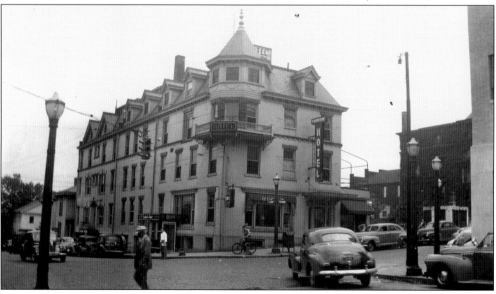

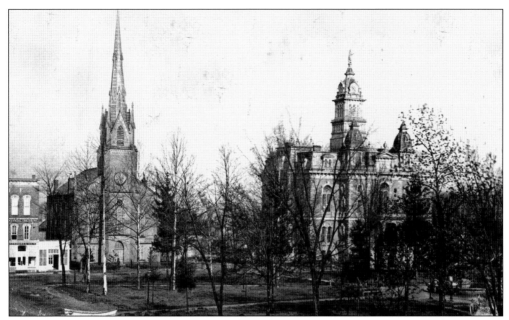

Towers and steeples dominated the east side of the square, from the First United Methodist Church and the Richland County courthouse. Both of them acquired new profiles on the skyline within a few years, the church repositioning its steeple to the corner and the courthouse removing all its towers to build a more waterproof top. (Richland County chapter, Ohio Genealogical Society collection.)

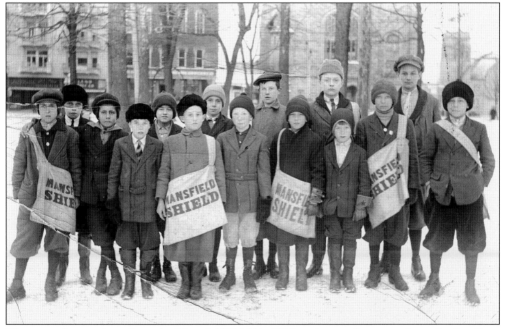

These are the newsboys from the *Mansfield Shield* in 1913 posing on the square just a few feet from the newspaper offices on North Park Street, and they carried the Democratic news in Mansfield. If one wanted the Republican side of the story, one had to read the *Mansfield News*, which had its own battery of newsboys. (Mansfield/Richland County Public Library collection.)

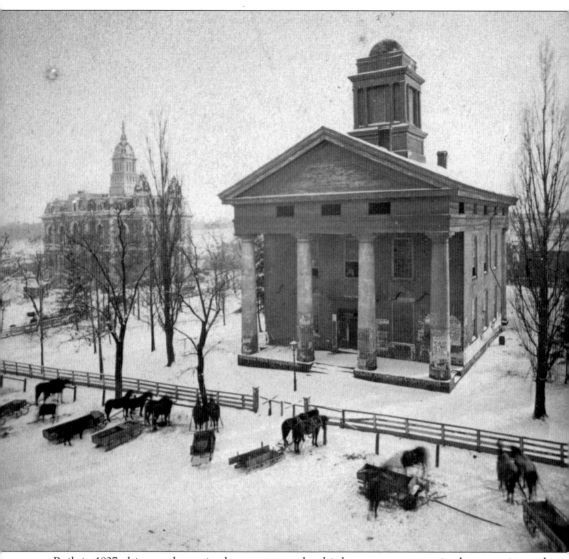

Built in 1827, this courthouse in the square was the third structure to serve in that capacity, and in the background is its successor, completed in 1873. In the foreground is the famous fence built around the square to protect the public grounds from roaming livestock. Erected over considerable protest by farmers who had been pasturing their herds there for years, it was removed shortly after this picture was taken, leaving only hitching posts surrounding the square. Merchants then began advocating for years the removal of all horse parking to liveries and grounds some distance from the square in order to improve the smell of the place. When the hitching posts were actually taken down, it was quietly in the middle of the night to avoid attention and protest, but there was a riot the following day nonetheless. (Phil Stoodt collection.)

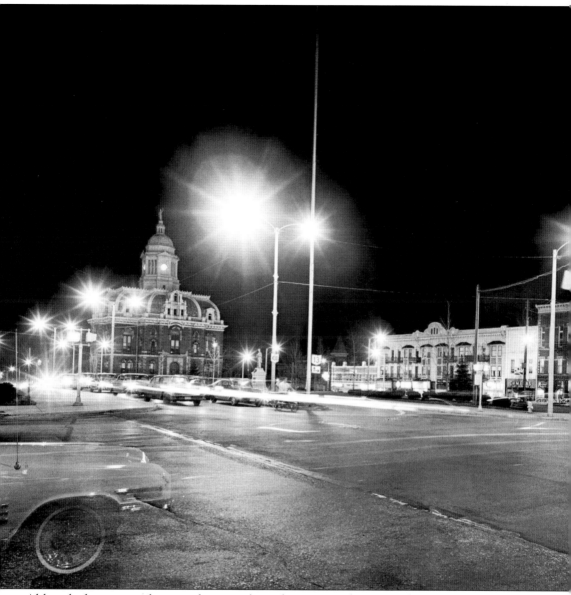

Although this picture does not date exactly to the 1940s and 1950s, it does give the sense of a predominant downtown activity from those decades, which was driving around the square. Every night on the weekends and often during the week, teenagers would pile into somebody's car, preferably whoever it was who had the convertible, and drive around and around the square. Like a merry-go-round, the traffic went counterclockwise, and likewise as well, all they were really able to do in this activity was wave at one another and shout back and forth. To this day no one who participated can tell exactly what it was they thought they were doing, other than it was the same thing everybody else was doing. It is just what they did. Today it takes place on the Miracle Mile. (Mansfield/Richland County Public Library collection.)

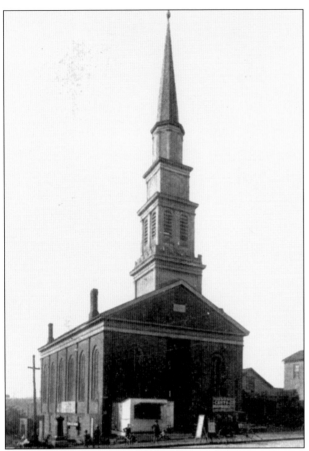

This was the only Presbyterian church in town until the Civil War, and then the minister made a long prayer for Union victory and half the congregation stomped out to start its own church. Standing on the southeast corner of the square, the building served in many capacities long after the Presbyterians moved to Mulberry Street, including sundry shops and the Salvation Army for a season until a saloon moved into the basement. During the 1920s and 1930s, it was an automobile repair place called the Park Garage, and in 1939, it was razed and replaced by the Park Theater. This children's matinee was photographed in 1946 during the movie house's height of popularity. By the 1960s, the movies were gone and the Park Building was a home for the Mansfield Fine Arts Guild before it built the art center, and then the building filled with office space. (Left, Mansfield/Richland County Public Library collection; below, Charles Miller collection.)

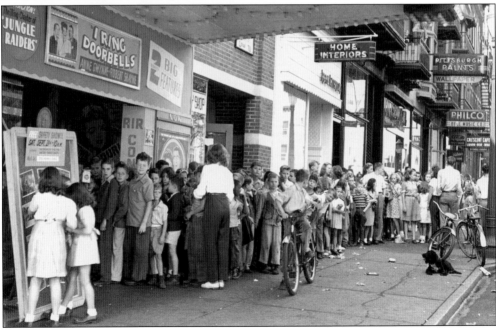

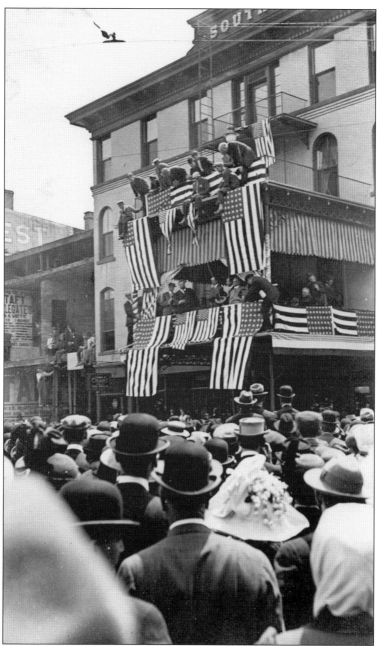

One sure indicator of how closely any presidential race is being contested in the popular polls is by keeping tally of how many candidates show up in Mansfield before the election. In 1912, there were two of them who made speeches in the square within 72 hours. On Wednesday, May 15, Pres. William H. Taft spoke from the bandstand and before the lawn had even been cleaned his opponent Theodore Roosevelt showed up on Saturday to have his say from the balcony of the Southern Hotel. The Republican newspaper in town, who was campaigning for Taft, reported that 3,000 people showed up to hear Roosevelt but the other paper counted 6,000. A close examination of the left side of this photograph reveals that Taft supporters were not without representation at this Roosevelt rally.

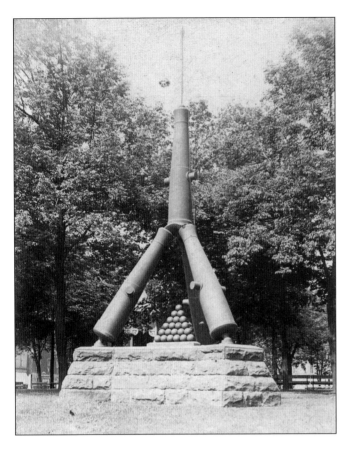

The square has always embodied the public memory as a place of war memorials, and this one was erected to commemorate the Civil War. The "gun monument," as it was called before it fell down, was made of four 8,500-pound guns manufactured in Virginia before it became part of the Confederacy. Designed for coast defense, the guns fired a ball seven inches across that weighed 42 pounds and could blast over a mile. (Mark Hertzler collection.)

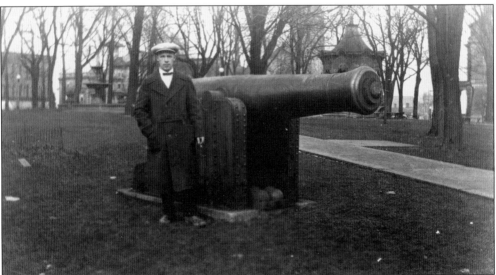

Today these cannons are found mounted in the courthouse front yard defending against invaders from the north, but for 70 years, they pointed out in four directions from the sides of the square. This one on the south side aimed directly into Prince's Lunch, which provided fodder for no end of little jokes about lousy customers or poor service. (Anna Marie Nelson McCracken collection.)

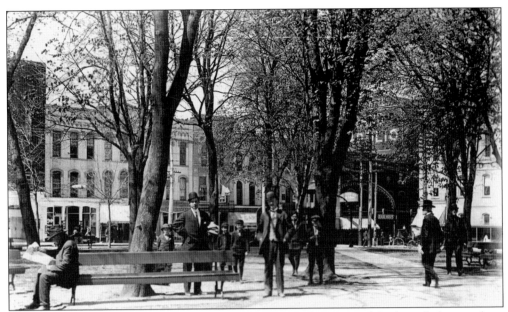

The "man on the street" in Mansfield was usually found in Central Park, and that is where reporters interviewed people in 1952 when *Time* magazine came to find out what the average American thought about the Harry S. Truman/Adlai Stevenson presidential race. In 1984, the *New York Times* came here to test the political temperament in the Ronald Reagan and Walter Mondale race. Had this picture been taken after 1925, it would include a monument noting that Abraham Lincoln got his first nomination for the presidential race at a convention here in Mansfield. (Phil Stoodt collection.)

A traditional Central Park landmark that is not seen there today is the old fire bell in the northeast corner of the park that had once hung in the tower of city hall. When the fire department moved to a new building in 1925, the bell was mounted in the park for kids to bang on and couples to pose in front of. Today it is in the Mansfield Fire Museum. (Mansfield/Richland County Public Library collection.)

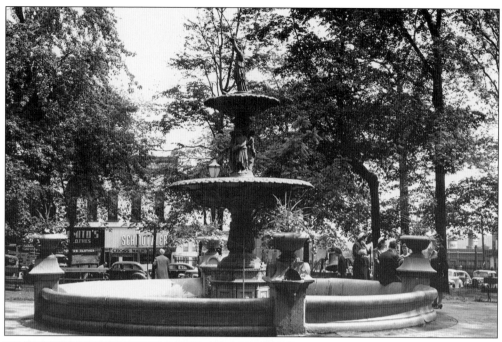

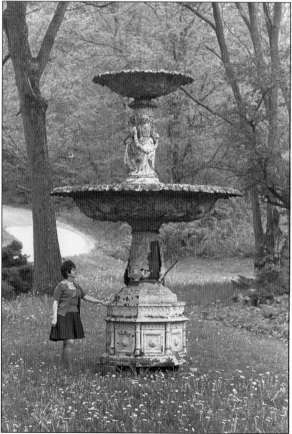

The Vasbinder Fountain was at the heart of Central Park from its dedication in 1881. Placed right in the center, it hearkened back to a day of public springs and civic watering troughs in a graceful Victorian manner. After 50 years, it was not weathering too well, and attorney George Biddle complained every day in the courthouse that it was a city disgrace and should be repaired or removed. One day he noted that his advice had been taken and the fountain had been restored, and when he got back to his office, he discovered that the city had sent him the bill. When the park was cut through in 1959, so that Mansfield could get Park Avenue designated as Route 30, the fountain was sent out to pasture, finding a home in a side lawn at Malabar Farm. (Above, Richland County chapter, Ohio Genealogical Society collection; left, Jeff Sprang photograph.)

Of all the family photographs taken in Central Park through all the years, the greatest number have somebody posing in front of the Vasbinder Fountain. Ask the older folks today who were kids back then what it is that they remember most about downtown and they all smile and tell about the goldfish in the fountain. (Eileen Wolford collection.)

One always hears about the swallows returning to Capistrano like some romantic love story or the buzzards returning to Hinkley Ridge like some wistful notion of going home for the holidays, but no one ever has an endearing word to say about the crows that come back to Mansfield every November to lay down a whitewash on the sidewalks around Central Park. The best thing to be said about it is that the town never has to fertilize the lawn. (Author's collection.)

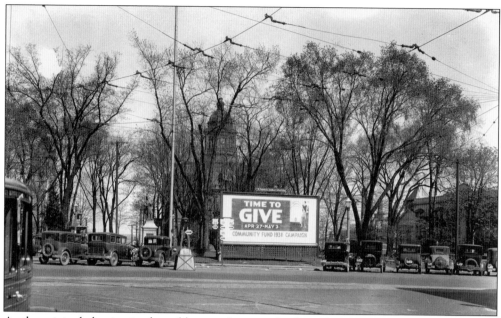

As the original clearing in the wilderness that gave birth to the community, the public square has always been the heart of Mansfield, and throughout the two centuries of the town's growth, that is where matters of the heart and head have been voiced as a community. What began in 1920 as the town's community chest providing sustaining funds for humanitarian organizations, ranging from the Salvation Army to the Playground Association, later became the war chest raising funds for World War II relief agencies, and eventually became the United Appeal and now United Way. In 1920, the community chest collected $35,000 to fund nine agencies, and in 2006, United Way raised $1.96 million to support 28 agencies, demonstrating just how strong the town's heart has grown through the years. (Above, Richland County chapter, Ohio Genealogical Society collection; below, Bob Carter collection.)

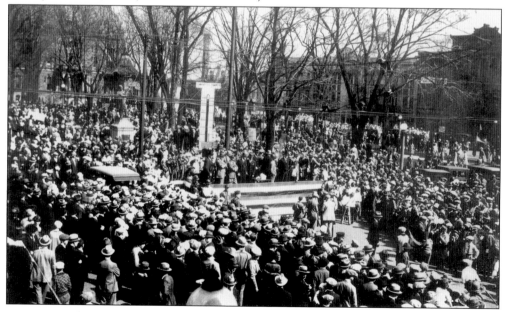

Four

PARK AVENUE AND WEST

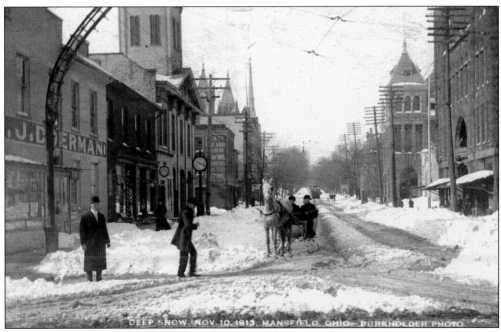

In 1913, when the great flood struck in the spring of the year, there was also a great and sudden snowstorm in November that blew up drifts five feet deep on North Main Street. In this photograph taken where Main meets Park Avenue West, the snow does not look so challenging and provides a charming view of life in Mansfield before snowplows. (Phil Stoodt collection.)

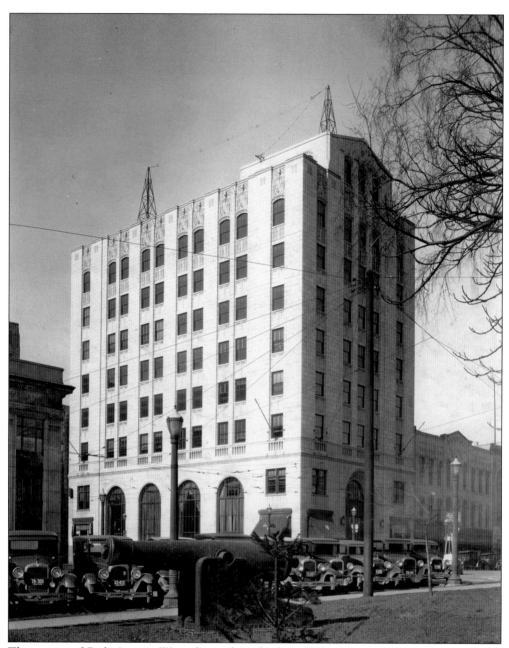

The nature of Park Avenue West changed in the late 1920s as economic vigor spurred new growth in Mansfield banks—in their vaults and volumes and also in their elevation. The Richland Trust Company, pictured here, gained sufficient altitude to inspire Mansfield's radio station to new heights. WJW, which had been broadcasting from the Southern Hotel, moved into the very top of the bank as soon as it opened in 1929 to send its signal farther than it ever imagined, receiving word of its clear reception all the way from Pittsburgh. (Danja Kindinger Thompson collection.)

As a contrast in how much Park Avenue has changed through the ages, here are two photographs taken from roughly the same spot looking in different directions in very different times. In the picture above the photographer stands just west of Walnut Street and looks east to the King Building in an era when shade trees sent their shadows halfway across Park Avenue, and, aside from horse manure, the only thing a pedestrian had to watch out for in the streets were streetcars that moved 10–15 miles per hour. The picture below was taken looking west on Armed Forces Day in 1961 after the street had been widened and all but stripped of trees. (Right, Mark Hertzler collection; below, 179th Airlift Wing archives.)

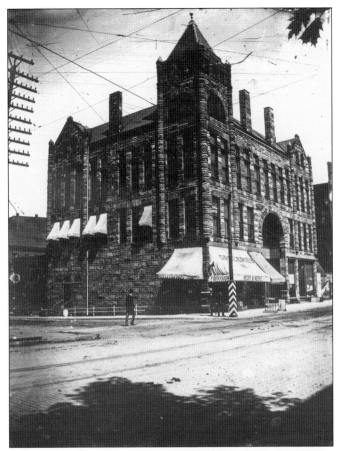

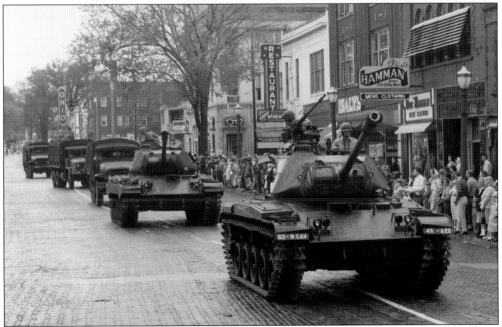

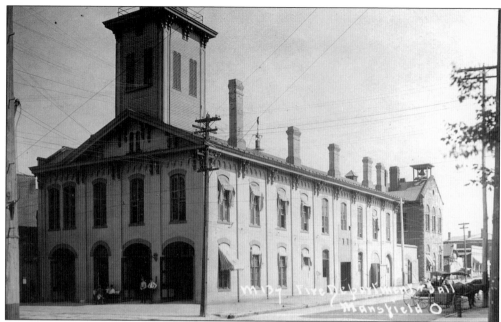

Mansfield City Hall, on the southeast corner of Park Avenue and Walnut Street, was constructed with a huge open market on its first floor that had stalls for produce and goods. Later the fire department operated station No. 1 in that space, its fire bell in the tower overhead. This photograph shows the front of the city jail as well, protruding from behind city hall at the right. (Phil Stoodt collection.)

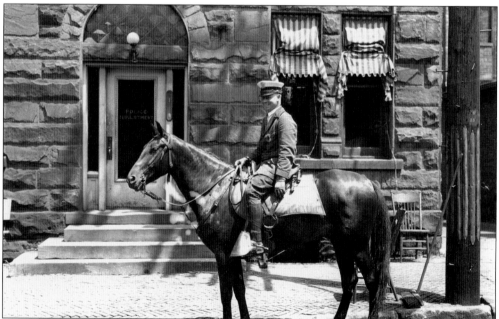

The Mansfield jail, called the city prison, was on Walnut Street behind the city building. This mounted officer is seen in front of the jailhouse, photographed in 1924 when Mansfield Police Department still had horses on its payroll even though the officers were accustomed to automotive transportation when they were not walking the beat. (Mansfield Police Department archives.)

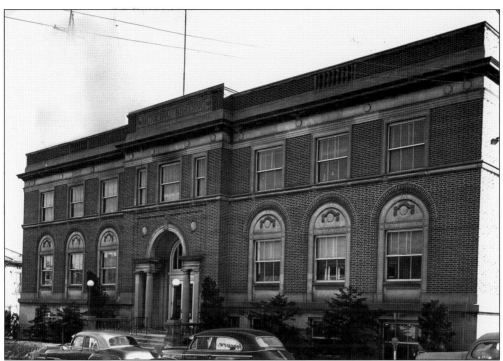

Built at Walnut and Second Streets, the new municipal building replaced city hall in 1924 to update city services with bigger offices and more dramatic courtrooms. Fire station No. 1 moved to the new site as well, and following a venerable tradition there were paving bricks taken from the floor of the old building where the fire engine parked and placed into the floor of the new firehouse. Seen in this photograph from 1930 (below) are the men and trucks of Company 3 from the Chestnut Street station, Company 2 from the flats, and Company 4 from the Newman Street station. (Above, Richland County chapter, Ohio Genealogical Society collection; below, Mark Hertzler collection.)

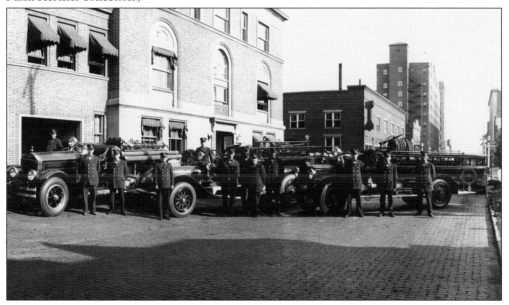

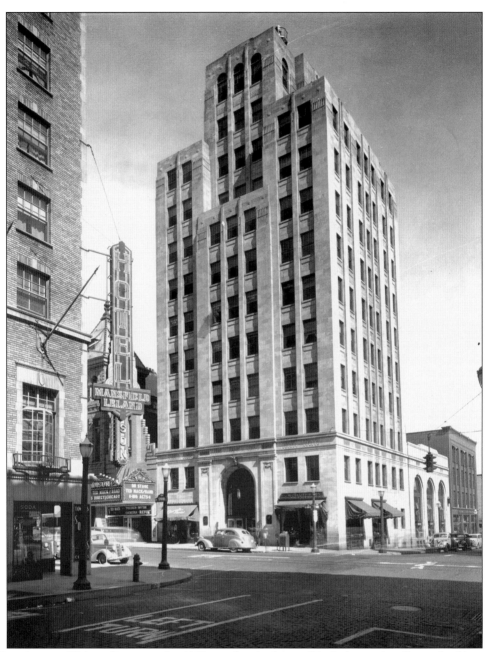

Standing on Walnut Street in the 1930s in the shadows of Park Avenue's tall new buildings, this photographer captured the dynamic surge of burgeoning civic hope that rose in Mansfield with the dawn of its new metropolitan aura despite the Great Depression that was casting a pall over the rest of the country. Mansfield's new era began in 1927 with the Mansfield Leland Hotel, built at the staggering cost of $556,000. It gave the town a certain sort of American big business legitimacy so that when the big boys came in from Hollywood or New York for Louis Bromfield's premiere or a Westinghouse showcase there was a grand lobby, a high-class lounge and a stylish ballroom for them to smoke cigars in. (Richland County chapter, Ohio Genealogical Society collection.)

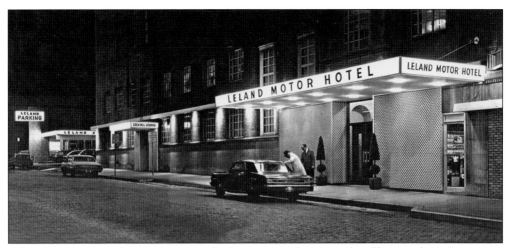

After the war, when the new interstate highway system kept travel traffic away from downtown, the Leland made changes in order to compete in a new generation: it called itself the Leland Motor Hotel, developed a parking garage, and added another 100 rooms. But ultimately the world had changed too much for the hotel to adapt to the times, and in 1975, it departed from the skyline. (Above, Dave Kearney collection; below, Jeff Sprang photograph.)

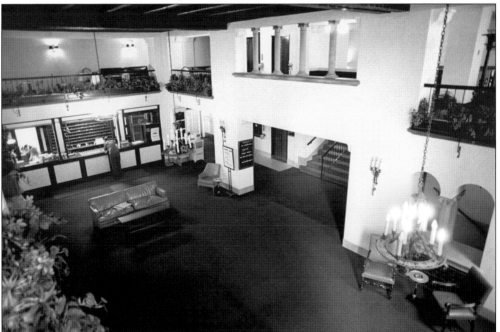

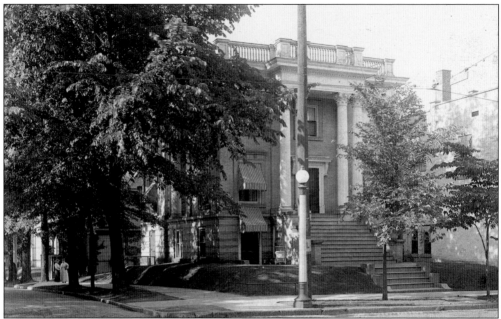

Of all the charming streets in Mansfield that passed with former generations, the most transformed is Mulberry Street. The office and home of Dr. John Nichols, this classic edifice that marked the entrance to North Mulberry, was built in 1905, gracing Park Avenue for 73 years before making way for a parking lot. (Billie Porter collection.)

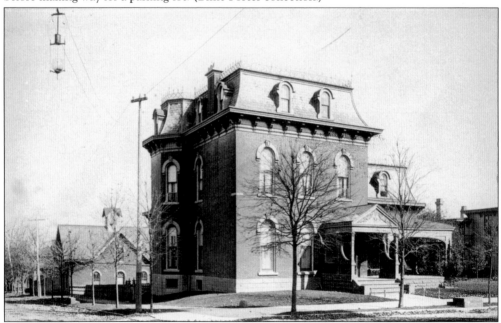

Another block north at the corner of Mulberry and Third Streets was the home of Abram Heineman. He made his fortune dealing in horses as may be evidenced by the huge brick stable and livery seen behind his home. This house eventually became the Elks Club for many years with a huge antlered concrete elk in the front yard and a massive ballroom attached in the backyard. There is an office building there today. (Mansfield/Richland County Public Library collection.)

It was not that long ago when one could stand at this intersection of Third and Mulberry Street and see eight steeples within a three-block radius from 10 churches, and the only thing blocking one's view would be the trees in summer. Many of them were solid bastions, like the First Presbyterian Church seen in both of these photographs, built of stone and leaded glass, that looked like they could last for centuries. No one could have imagined back then that within a couple short decades all but two of them would fall victim to the urban migration of the 1960s. (Above, Phil Stoodt collection; right, Mansfield/Richland County Public Library collection.)

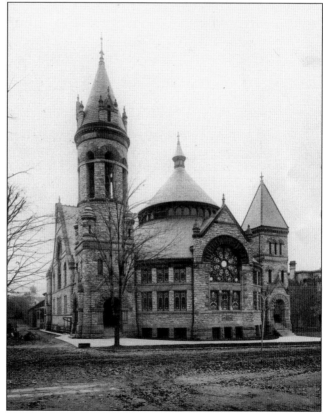

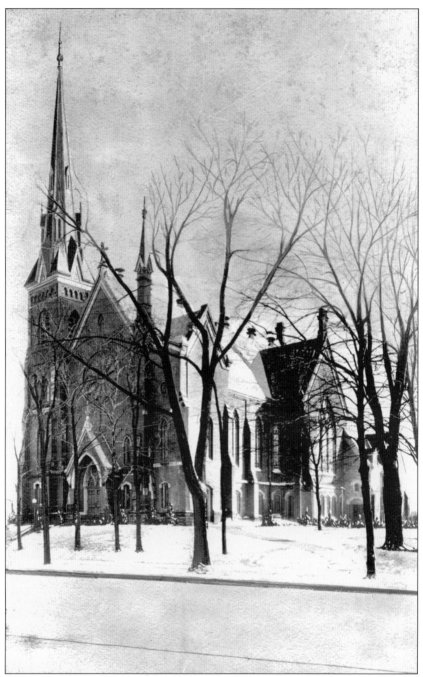

When the Congregational church was built, it broke ground at 14 feet above street level on Park Avenue and spired up 215 feet so that it could be seen from the railroad station and from every highway coming in to town. Many old photographs can be identified as to location by their relationship to the unmistakable spire in the background—provided the picture was taken between 1873 and 1942 while the church stood. It took three years to build and only hours to burn, and it was missed long after its passing for the ornate woodwork inside and the particular resonance that voices carried singing from its lofts. (Bob Carter collection.)

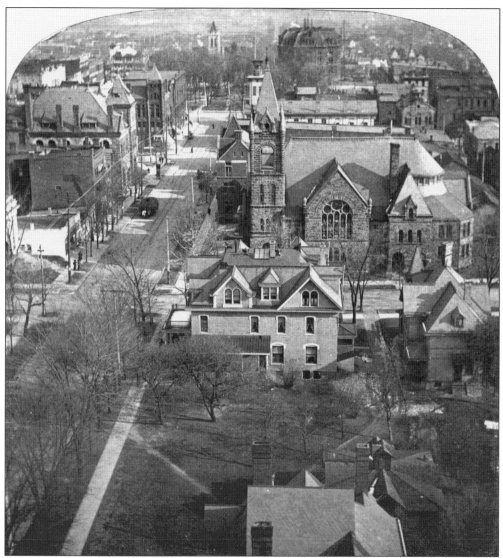

Someone climbed clear up into the steeple of the Congregational church with a camera and photographed the view looking east toward the square. Not only that but it was a stereopticon view photograph, which requires an extra big camera that the photographer had to haul up those ladders in order to provide this bird's-eye view of Mansfield. The photograph is not dated, but there are certain deductions one can make by way of understanding the history of Park Avenue: there are no parking lots in evidence so it is before the 1970s, the street is still lined with trees so it is before 1950, the Congregational church spire is still standing so it is before 1942, there are no skyscrapers in sight so it was before 1927, and the courthouse does not have a tower on top so it has to be between 1902 and 1909. (Richland County chapter, Ohio Genealogical Society collection.)

For an idea of how much Park Avenue has changed in the last 100 years, go to the five-way light at Bowman Street and Sturges and Marion Avenues and take a look south and east at the views photographed here around 1900. The home in the picture was the Weavers' and it stood up on the grassy hill where a huge hotel was built in the 1960s. And the enchanting street is Park Avenue looking toward the square after a snow has brought the limbs low. If this sounds like a lament and one is tempted to pine for those lost days, just bring to mind the fact that the year these photographs were taken 37 people in town died of cholera or tuberculosis, so while it may have been more idyllic appearing back then, life was far from ideal. (Above, Mansfield/Richland County Public Library collection; below, Mary Beard Herrick collection.)

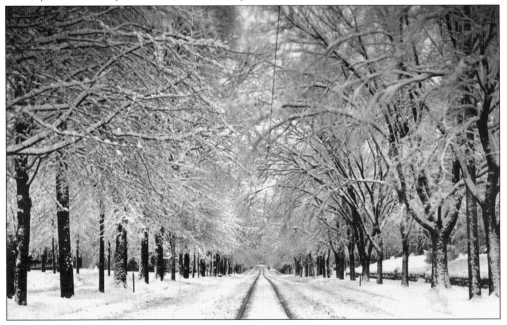

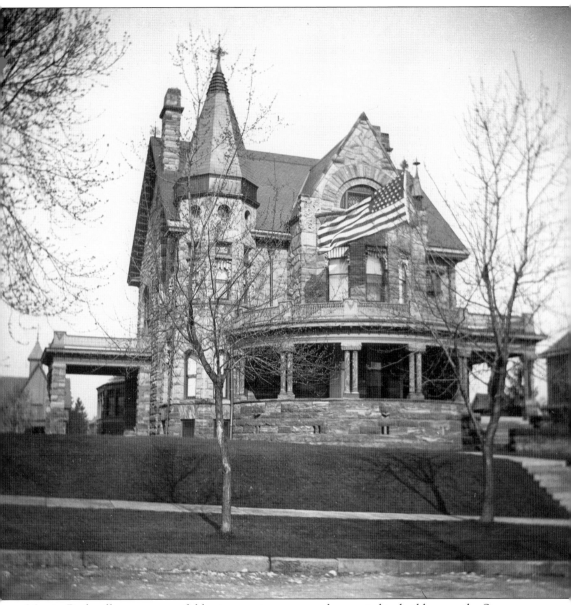

Martin Bushnell was a successful business entrepreneur who wanted to build up on the Sturges Avenue hill, but he did not want just any ordinary mansion, so he bought a quarry north of town known for its particularly brilliant pink and red sandstone and had his entire house crafted from the stone. It still stands today, listed on the National Register of Historic Places. (Betty Angle Fox collection.)

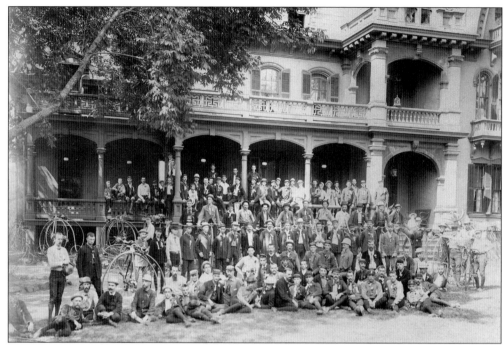

When attorney John Sherman became Representative Sherman and then Senator Sherman in 1861, he spent much more time in Washington, D.C., and less time around Mansfield. He did build a new residence here, though, and to reflect his growing stature in national affairs, his house was by far the biggest mansion in town. For an idea of just how large it was, here is an 1887 photograph of the entire League of American Wheelmen on his lawn, where they stopped to pose on their Ohio tour. The grounds were no less impressive either as seen from this photograph taken shortly after his death when his backyard was being marked off and subdivided into several large neighborhoods known collectively today as the Sherman Estate. (Above, Mark Hertzler collection; below, Richland County chapter, Ohio Genealogical Society collection.)

The other senator from Mansfield was actually born here. Sherrod Brown came up through the Mansfield city schools, was a Boy Scout in the Congregational church troop, and grew up in this house on Marion Avenue. He announced his political career to the town ambitiously enough by knocking on 20,000 doors during his first campaign for the state legislature. Seen here receiving his Eagle Award from John Glenn in the Leland Hotel, Brown as a congressman encountered Glenn years later when they both had offices in Washington, D.C., as members of the national legislature. After 14 campaigns for public office and 32 years of public service that took him far from home fighting for the working man, Brown's very first speech on the floor of the U.S. Senate began with these words: "Mr. President: I grew up in Mansfield, Ohio." (Emily Brown collection.)

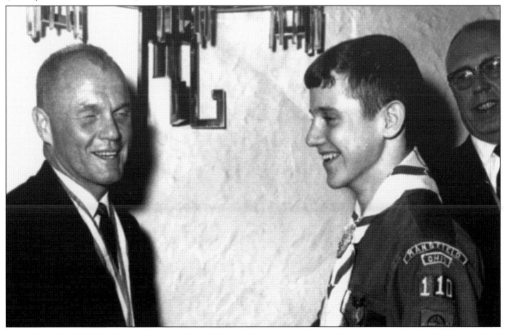

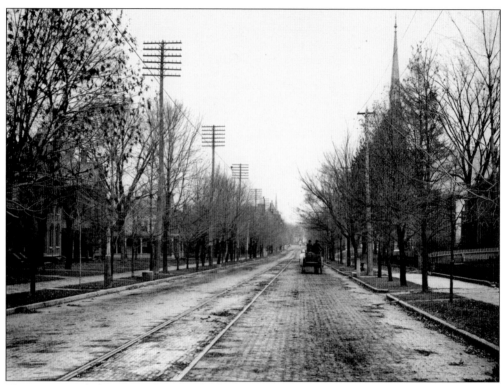

The nature and character of Mansfield changed dramatically after World War II when a new generation of leadership tempered by the war came back to usher the town into modern times. A great deal of what had been seen as small-town charm became viewed as old-fashioned and not progressive, and within 25 years, a lot of downtown was knocked down and hauled away. One of the casualties of this revolution was the pleasant tree-lined homey atmosphere of Park Avenue when the street was widened in 1950 to allow more lanes of traffic. The photograph below was taken in 1922 west of town on what was to become the Miracle Mile, the same stretch of road today seen on the facing page. (Above, Mansfield/Richland County Public Library collection; below, Billie Porter collection.)

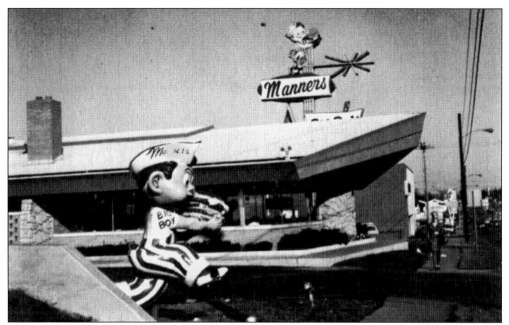

The most miraculous aspect of Park Avenue West was that people could go Christmas shopping without spending their first hour looking for a parking space; the great plains out past Trimble Road in the 1950s and 1960s offered boundless opportunity for acres of blacktop neatly lined for row after row of family cars. One by one, the downtown department stores migrated west to the Miracle Mile, where the intervening spaces filled with drive-throughs, banks, bank drive-throughs, and all manner (and Manners) of restaurants to create a marvelous mile of consumer heaven. (Above, Mansfield/Richland County Public Library collection; below, author's collection.)

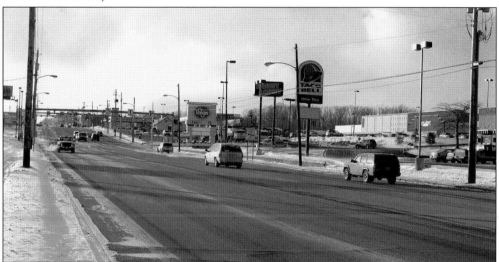

After author Louis Bromfield won the Pulitzer Prize in 1927, he wrote a fictionalized history of Mansfield called *The Farm* based on his experiences at a family farm off Fourth Street west of town. The house on the farm in his novel, seen in this painting by illustrator Kate Lord and visible today from Home Road near the fairgrounds, was the original inspiration of architectural style upon which Bromfield based his own big house at Malabar Farm when it was built in 1939. (Author's collection.)

By the time this picture of Louis Bromfield was taken in 1943, he had already written many of the 30 best-selling books of his career and was respected around the world as an accomplished author and earnest activist in politics and agriculture, yet it is clear to see that through his fame and stature the man never lost the fun-loving grin of the boy who grew up on Third Street. (Author's collection.)

Five

THE PARKS

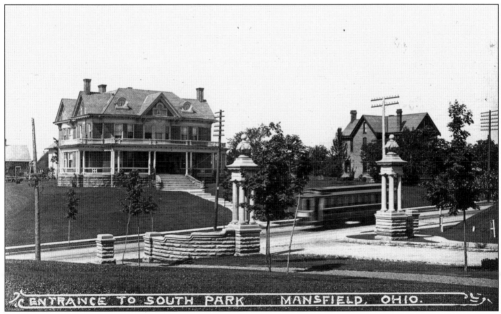

The main east–west thoroughfare passing through Mansfield was named Market Street at the beginning of the city's history, but in 1888, it was renamed Park Avenue because it went from Central Park on the square to the Sherman-Heineman Park at the western edge of town. Known today as South Park, Middle Park, and North Lake Park, this series of wooded glens and scenic drives was so far out in the country back then that it was nearly a dozen years before the streetcar line was extended out that far. (Phil Stoodt collection.)

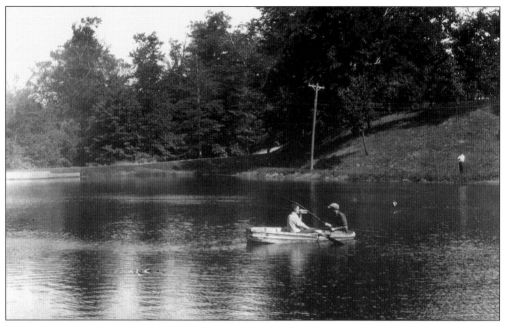

Maple Lake Park is an athletic field today with basketball and tennis courts, but it got that name honestly back in 1905 when the city acquired the little valley at the end of South Park and made preparations to flood it. It took three years to get the waters to behave, but once it was finished, Maple Lake was a favorite boating and fishing resort in the summer and skating pond in the winter. (Bob and Wanda Donnan collection.)

Maple Lake was always somewhat problematic from the start, and after 30 years, it became a WPA project to dredge it out so it would be more like a lake again and less like a swamp. Ultimately the swamp prevailed, however, and the frogs were keeping everyone up all night, so the lake was filled in 1951. (Bob and Wanda Donnan collection.)

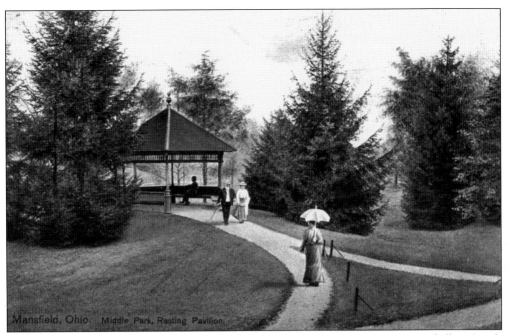

The octagonal gazebo in this picture can be seen today above Park Avenue on a hill in South Park at Brinkerhoff Avenue, where it has been for the last 20 years, but when this postcard view was made in 1908, the gazebo was in Middle Park, where it stood on a small knoll surrounded by a modest screen of evergreens. (Mary Beard Herrick collection.)

This photograph captures the same site as it looks today, showing those modest Norway spruces to have grown a full 80 to 100 feet above the gazebo knoll in the last 100 years. The intervening years have obliterated the ornamental paths and garden beds from back then, but they have served to deepen the Middle Park groves into a shady forested preserve. (Author's collection.)

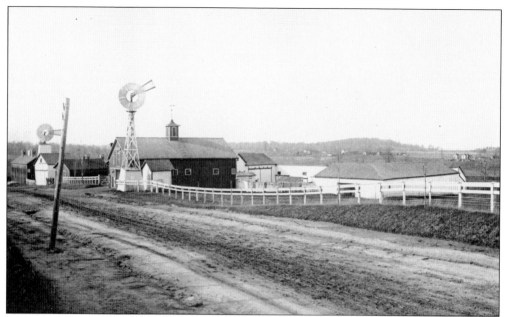

The pastoral scene in this 1894 photograph was the horse paddock for Abram Heineman's lucrative business selling horses to the U.S. Army and to cities in the East in the years before automotive travel when everybody had a horse. This same place today has residential streets in the neighborhood rising from North Lake Park. (Mansfield/Richland County Public Library collection.)

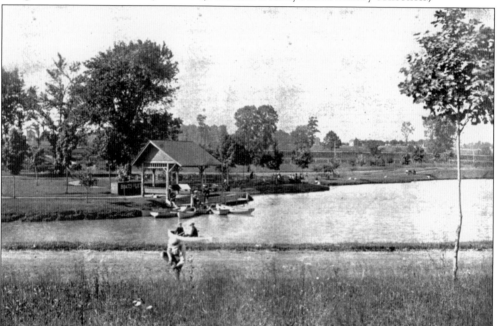

Heineman donated this land to Mansfield in 1888, and combined with the land for South Park donated by Sen. John Sherman, the new park system was known for many years as Sherman-Heineman Park. The stream that ran through the bottoms was permanently dammed to create the park lake, and, as seen on the sign, there were boats to let for many years. (Mark Hertzler collection.)

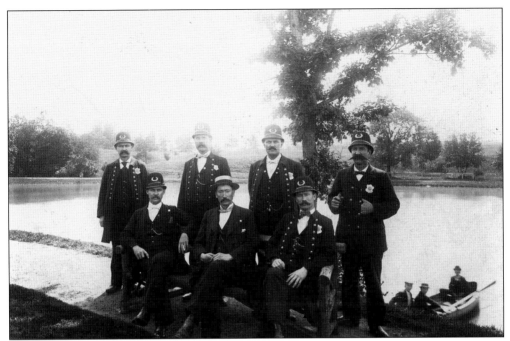

Enjoying an outing in 1896, the Mansfield Police Department sits for its portrait by the waters of North Lake. The population of Mansfield on that day numbered 15,034, and the entire police force was these seven men if that gives any idea of what a different world it was back then. (Mansfield Police Department archives.)

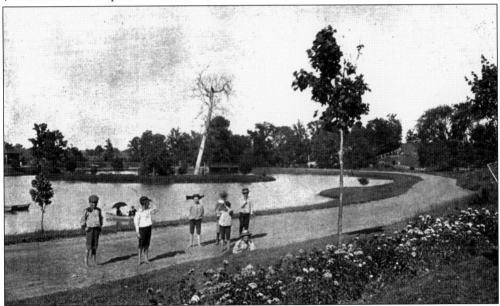

This view of the east end of North Lake shows the grassy hillside rising to the right where one day Rowland Avenue would be established, but in 1901, it was a golf course. When Westbrook was laid out in these horse pastures there were still paddock fences interrupting play through the fairways, and little ladder bridges were constructed for ladies and sportsmen to climb over on their way to the greens. (Mark Hertzler collection.)

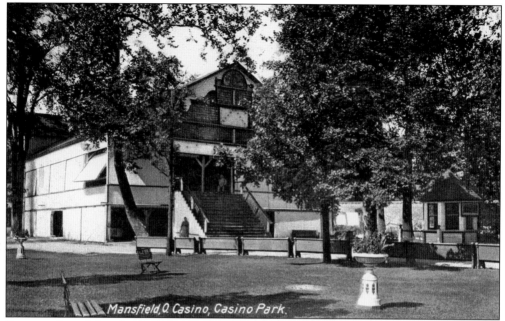

For a number of decades the North Lake Park area was known as Casino Park because of this theater and amusement complex. Built in 1893, the theater upstairs was known for summer vaudeville and cheap opera and had a grand stairway leading downstairs to a restaurant and dance hall. Although it was destroyed by fire in 1934, it was still called Casino Park by generations who never even saw the theater. (Phil Stoodt collection.)

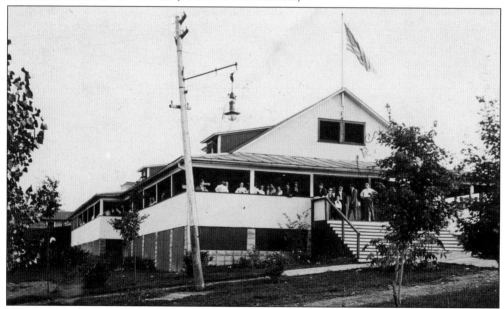

The White Maple dance hall was in the park on Westwood Drive, and for 20 years it was the hopping place to be in town. During that age of town bands and brass ensembles, the dance floor was a lively place as ragtime was coming to life; however, in 1912, Mayor O'Donnell and Chief Feeney banned certain dances in Mansfield including the turkey trot, the bunny hug, and the come-back-kid. (Mary Beard Herrick collection.)

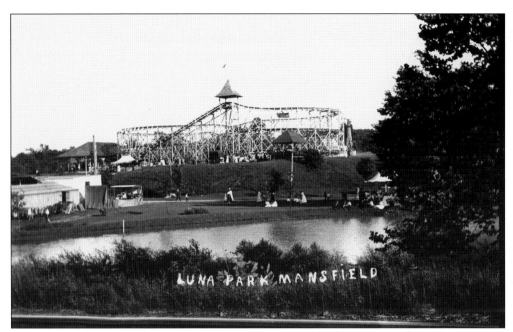

The Mansfield Power and Electric Company ran a streetcar clear out Fourth Street to Casino Park, and to give people a reason to ride more often, it created a whole valley of amusements called Luna Park. This photograph, from what is today the Richland B&O Bike Trail, shows the figure-eight roller coaster and some midway refreshment stands next to the swimming pool and fun house. (Bob Carter collection.)

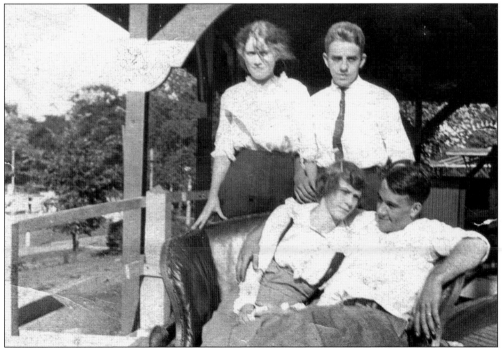

In 1917, roller coaster riders sat in comfy chairs, and it would be years before anyone thought of seat belts. (Adelia Van Geem Hautzenroeder collection.)

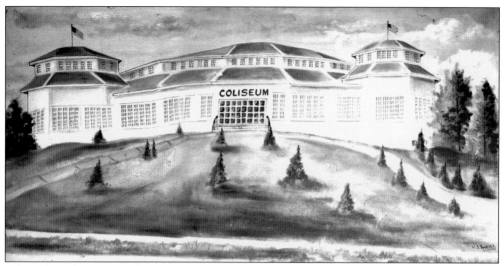

When the White Maple dance hall burned in 1921, a new and grander dance hall was conceived to take its place: the Coliseum. The roller coaster was taken down to make way for this colossal music hall where some of the greatest bands of the day performed to crowds of thousands. In later years, the Coliseum was primarily a roller-skating rink, and after it burned in 1967, someone with fond memories painted this portrait that hung in the new Coliseum until it too burned. (Author's collection.)

A new modern roller coaster was built for the park in the late 1920s, starting behind the Coliseum to race all the way up the valley to Fourth Street and back. The hairpin curve end of it can be seen in the background of this photograph, taken of some athletic boosters who are standing in Davey Field next to Fourth Street near Mansfield Senior High School. (William McKee collection.)

For many years, boating was so popular at North Lake that a grander boathouse was built on the north shore, constructed out over the waters so that boats could be rowed right inside. Generations of Mansfielders passed in and out of that boathouse not only in boats but also on ice skates. Skating was such an important part of winter here back then that special floodlights were erected in 1938 for night skating, and special park volunteers tended the burning barrels inside the boathouse for skaters to warm themselves by the fire. (Richland County chapter, Ohio Genealogical Society collection.)

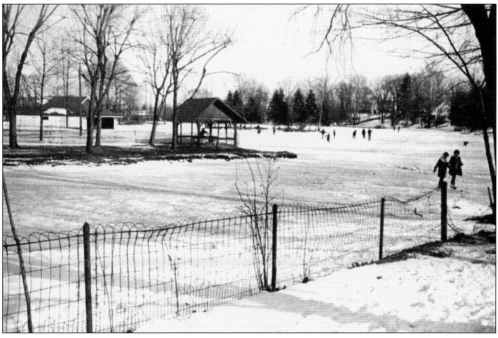

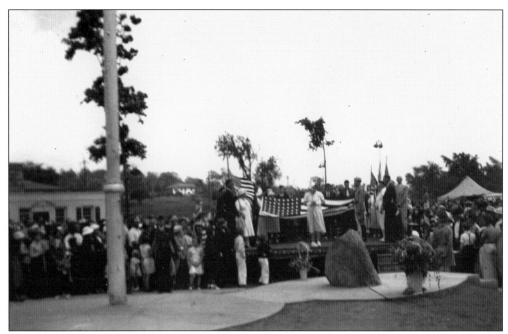

Liberty Park is unique among all of Mansfield's parks as having originated in the imagination of the people who lived in the area and wanted a park close to home. They raised the money to buy it themselves, which took five years during the Depression, with bake sales, fund-raising picnics, minstrel shows, and walking door to door collecting nickels and dimes. They purchased 24 acres and then with the help of a WPA project created the pool and the lake there, presenting it all to the city on the day these photographs were taken in 1937. (Mansfield/Richland County Public Library collection.)

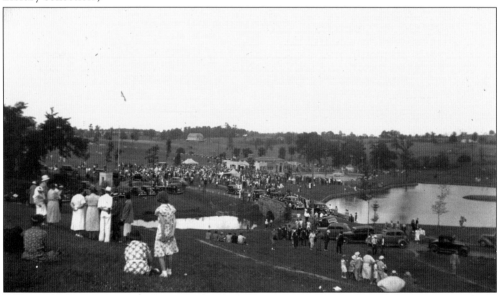

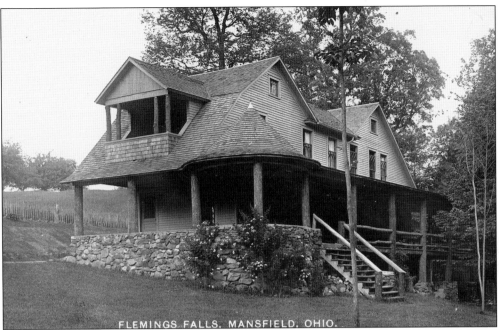

FLEMINGS FALLS. MANSFIELD, OHIO.

Before there was a park system in Mansfield, people got their sunshine at a beautiful forested ravine a few miles northeast of town called Fleming Falls. Originally known as Spruce Falls in the earliest generations, it was the site of a gristmill operated by John Fleming and a popular resort from the 1840s to the 1920s. An interurban streetcar line passed nearby making it easier to get there at the beginning of the 20th century, so excursion parties from all over the northern part of the state frequented the park as well. With the opening of Sherman-Heineman Park in town, Fleming Falls gradually fell into obscurity, in time finding use as the Boy Scout camp and then a church camp. To this day, large cuts in the stone at the top of the falls still mark the place where the waterwheel was placed for the Fleming Mill before floods and time washed it all away. (Phil Stoodt collection.)

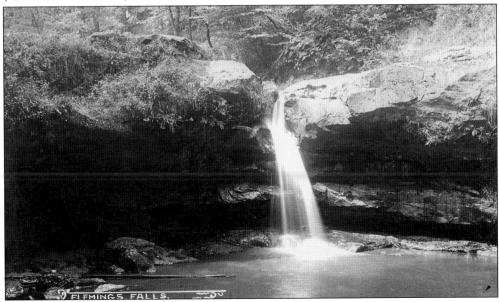

FLEMINGS FALLS.

The Woodland area of Mansfield was once the farm of James Dickson, his original farmstead located on Stewart Lane. This view of the Dickson home was photographed before any of the roads were laid out in Woodland from the lane that was to become Chevy Chase Road. The Dicksons developed lovely landscaped gardens near their house that were so remarkable that tourists rode out into the country to view them, and photographs of the sunken beds appeared in magazines and on postcards. Some of the stone walls and earthworks features of the Dickson gardens are still in evidence today in the backyards of homes in the area where Stewart Lane crosses Dickson Parkway. (Above, author's collection; below, Richland County chapter, Ohio Genealogical Society collection.)

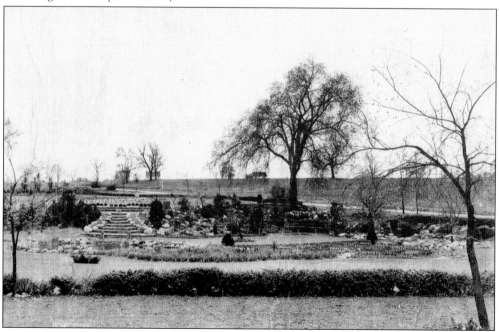

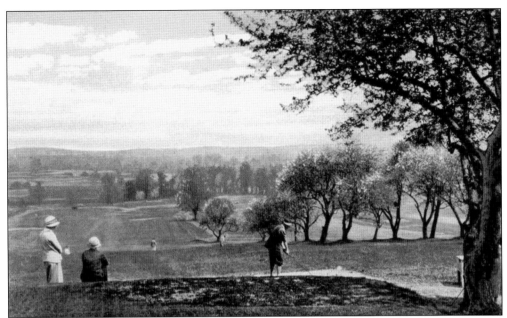

The first tee at Westbrook looked down over endless farmland and a country estate called Roseland back in the 1920s when this postcard view was made, and it was so far out of town past the fairgrounds that no one ever dreamed a day might come when the scenery would not be pastoral and rustic. As the years went on and Mansfield expanded its horizons, that rural postcard view gradually filled up with thousands of acres of steel mill and the neighborhoods of town long referred to as Little Kentucky. (Author's collection.)

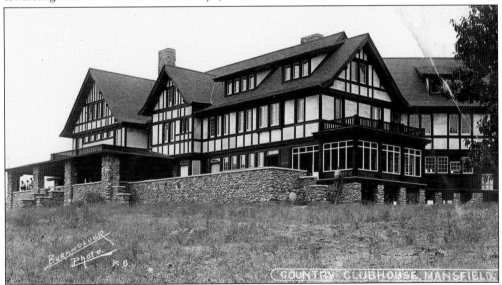

This clubhouse at Westbrook, which was destroyed by fire in 1941, was designed by Vernon Redding, the town's most distinguished architect. During a career of 40 years in Mansfield, he designed at least 60 buildings here and in nearby communities, many of which are still used today. In this book there are at least seven of his buildings pictured, including the Leland Hotel, Mansfield General Hospital, the municipal building, Ford Flats, and the Mansfield Public Library. (Phil Stoodt collection.)

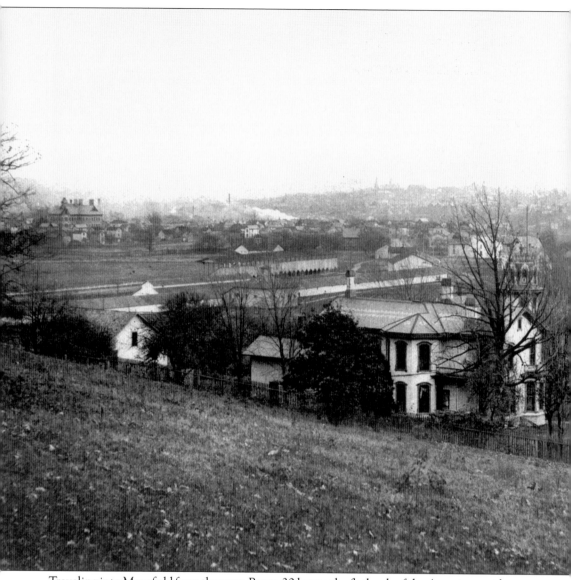

Traveling into Mansfield from the west, Route 30 leaves the flatlands of the American midwestern plains and crosses into the rolling landscape of the Allegheny Plateau. The very first landmark foothill marking the end of one world and the beginning of another is a familiar sight at the Springmill Street exit and is what is still called Lumberman's Hill, which today houses the Embark offices and Westbrook Country Club. It was originally known as Geddes Hill, the home of Judge George Washington Geddes before Lumbermans Insurance turned his home into its home office. This view from the southern slope of his hill looks into town over the former fairgrounds, where one would see Route 30 today. The grandstands are visible in the middle of the picture, and the large building to the left was the Bowman Street School, today known as the Ocie Hill Center. (Mansfield/Richland County Public Library collection.)

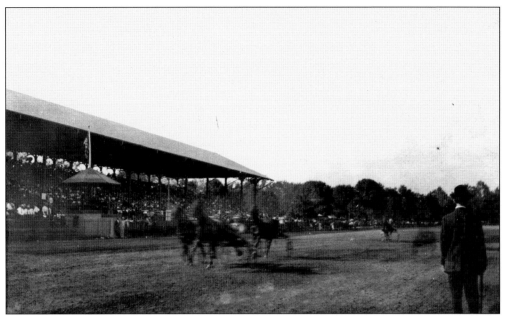

These grandstands were built at the Richland County Fairgrounds in preparation for the state fair back when that event moved from town to town, and Mansfield played host to the whole state in 1872 and 1873. There was a ball diamond there, inside the racetrack infield, where Mansfield fielded teams off and on for 50 years in the Ohio State League. Another league park, pictured below, was on Newman Street where Mansfield Tire was built. (Above, Phil Stoodt collection; below, Mark Hertzler collection.)

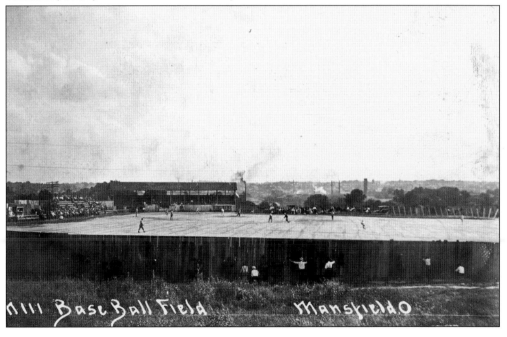

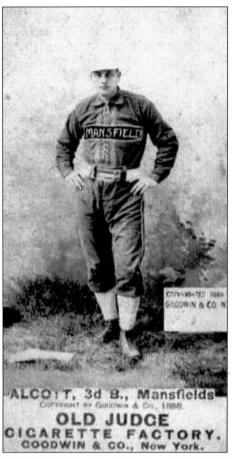

ALCOTT, 3d B., Mansfields
COPYRIGHT BY GOODWIN & CO., 1888.
OLD JUDGE
CIGARETTE FACTORY.
GOODWIN & CO., New York.

Mansfield is not thought of as a baseball town today, but it is in the baseball hall of fame for having hosted the first-ever professional baseball game in America when the Cincinnati Red Stockings played the Mansfield Independents here in 1869. When the first photographic baseball cards were issued in 1888, the set included a star third baseman from the Mansfield team. The picture below from 1919 was taken from the grandstands of Davey Field where the historic game had been played 50 years before. Built by the Davey brothers, who owned the steel mill, the park was home for the industrial leagues in town and later for senior high school teams. The hill seen in the background of this photograph was a steep grade of Fourth Street that was eventually eliminated when the bridge was constructed between Mansfield Senior High School and Arlin Field, the bridge abutments burying much of the outfield and the stream routed right through the pitcher's mound. (Left, author's collection; below, Mark Hertzler collection.)

Six

MOVING THROUGH TIME

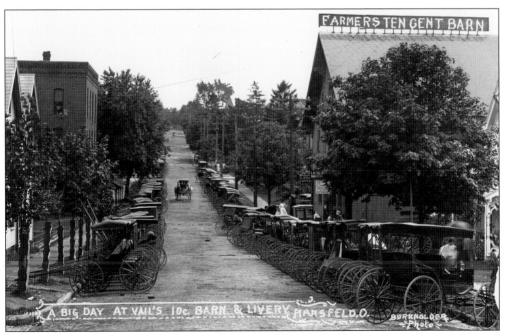

When this photograph was taken on South Diamond Street in 1908, everybody had a horse and only the rich people had cars. Within 50 years, everyone had a car and horses were not allowed in town anymore. Romantic as those slower-paced olden times seem, the streets smell much better today. (Phil Stoodt collection.)

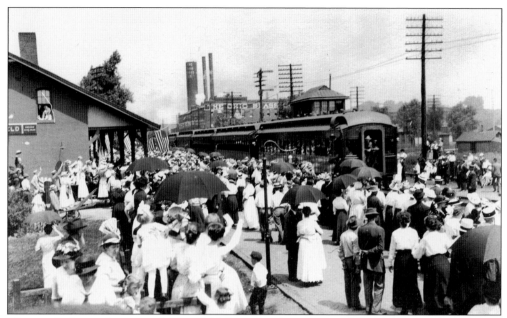

The single factor that turned Mansfield from an obscure country village into a vital urban center was the coming of the railroads, making the town viable for industrial growth through distribution and giving it an access road to and from the whole country. In this photograph, a crowd gathers where the Erie and the Pennsylvania Railroads combined to build the Union Station. (Phil Stoodt collection.)

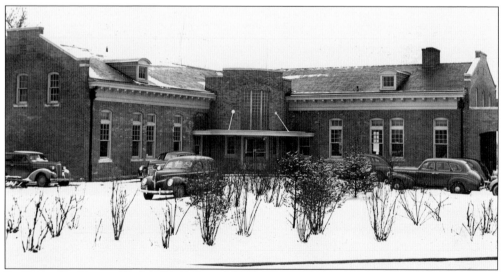

By 1900, after 50 years of increasing railroad traffic, Mansfield was seeing 33 passenger trains and 125 freight trains every day. This traffic divided between the Baltimore and Ohio, which had its station on North Mulberry Street, and the Union Station off North Diamond Street, seen here. (Richland County chapter, Ohio Genealogical Society collection.)

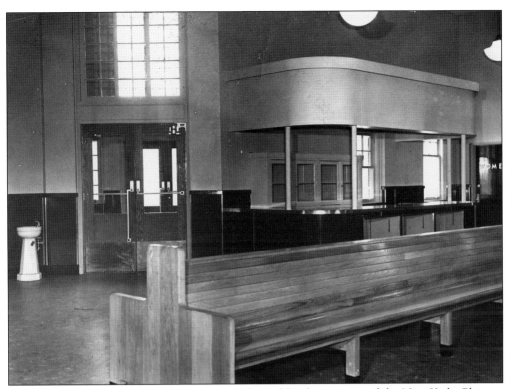

The Union Station was situated in the angle formed by the crossing of the New York–Chicago main lines of both the Erie and the Pennsylvania Railroads. Built originally in 1869, it looked like a relic once Ohio Brass built attractive new buildings nearby, so it was totally remodeled in 1941 to give it a streamlined and modern design. The wings of the building were each given a passenger waiting room, ticket window, and baggage room, and a subway was created for westbound passengers to cross underneath the railroad bed to get to the other side of the tracks. (Richland County chapter, Ohio Genealogical Society collection.)

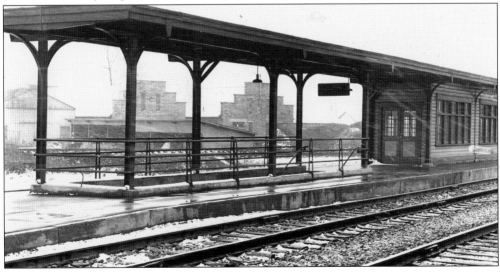

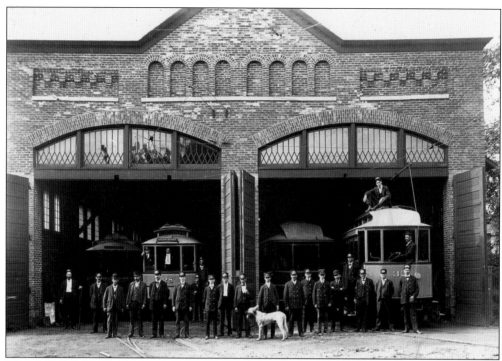

Mansfield developed a streetcar line in 1887 and was one of the first in the country to operate it with electric power. More than just a modern convenience, the streetcar industry proved to be a huge element in the city's economic growth as the Mansfield Brass Works retooled to make trolley parts and emerged as the innovative and nationally influential Ohio Brass Company. These two photographs of Mansfield trolleys depict the streetcar barn on East Fourth Street and the Springmill Street run showing the single pole connecting to a line overhead, which, when combined with the current of the steel rails, completed a circuit to power the trolley. (Phil Stoodt collection.)

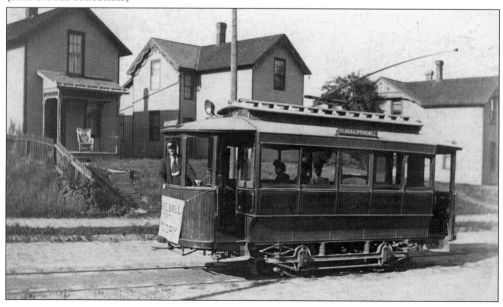

The streetcars that ran between cities were called interurbans, and Mansfield's lines ran to Shelby, Galion, and Ashland locally, with connections about anywhere one wanted to get in the state. The interurban station pictured here was at the corner of Third and Diamond Streets where there was a small lunch counter in the waiting room. In later years, this building held offices for an advertising firm and finally the Ringside Tavern. (Phil Stoodt collection.)

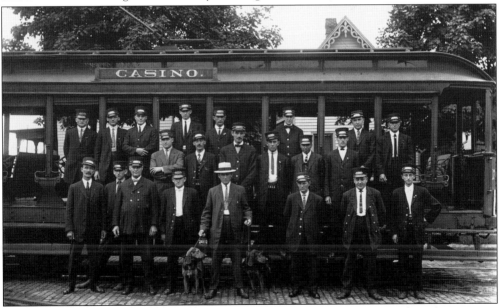

Mansfield streetcars were designed to accommodate the Ohio seasons, and on hot summer evenings, folks would ride around in the open-air Casino Park line just to feel the breeze blowing through. The last streetcar ran here in 1937, and during the ensuing years, the steel tracks were torn up by the city and donated to the war effort. (Phil Stoodt collection.)

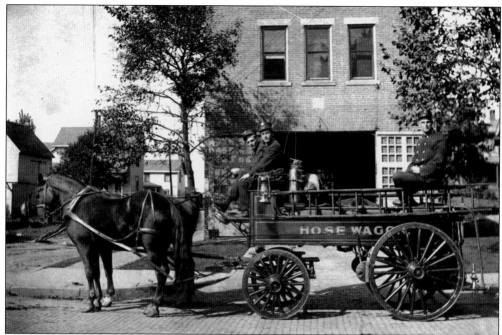

These photographs of the Mansfield Fire Department show firefighters from different eras that were not too far apart: Company 1 driving horses developed by the military to draw caissons and heavy equipment and Company 2 in its first automotive fire engine. The horse-drawn years ended around 1913, and at that time Mansfield had four fire companies: Company 1 downtown, Company 2 in the flats, Company 3 on Chestnut Street, and Company 4 on Newman Street. The Mansfield Fire Department reached a maximum of nine stations by the 1970s, acquiring stations through the years at Marion Avenue, Springmill Street, Brookwood Way, Sunset Boulevard, and the airport. Five of these stations make up the force today, continuing a proud tradition that dates back to the first volunteer company formed in 1831 with a hand-cranked engine. (Above, Mansfield Fire Museum; below, Phil Stoodt collection.)

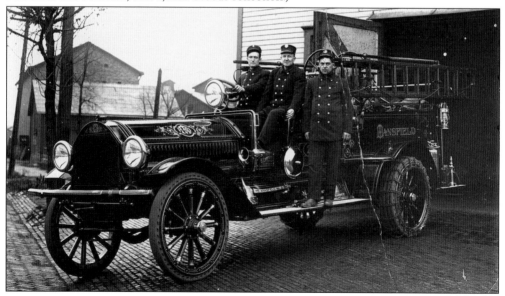

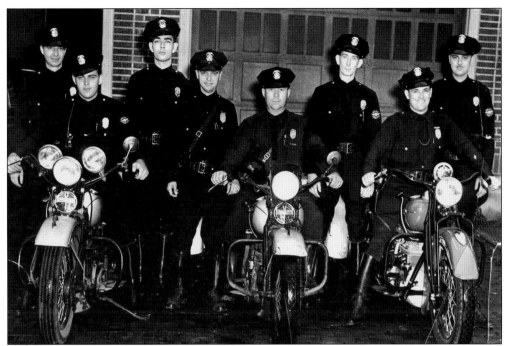

The Mansfield Police Department had been in automotive cruisers for many years by the time this photograph was taken, but it is clear from the officers' expressions how much they enjoyed being motorcycle cops. Motorcycle gangs of all sorts and numbers have frequented Mansfield through the years, and portraits survive of them showing off from every decade. The occasion of this panoramic shot in front of the courthouse downtown was the Mansfield motorcycle picnic in 1920. (Above, Richland County chapter, Ohio Genealogical Society collection; below, Mansfield/Richland County Public Library collection.)

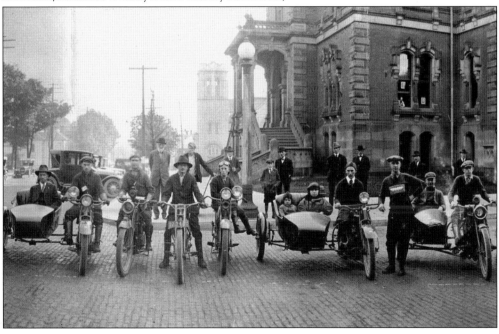

A Mansfield woman who had seen all but the first 19 years of the 20th century made this comment, "When I was young there was a church on every corner . . . then there was a filling station on every corner; now there's a pharmacy on every corner." It is a telling statement and it aptly illustrates the odd fact of the town that so many churches became automotive garages or, as in the case of St. Matthews Church on Park Avenue pictured here, turned into automobile dealerships. There was a church on Park Avenue East that was torn down to build a filling station, then a couple generations later a filling station on the corner of Trimble Road and Park Avenue West was torn down to build a pharmacy. The cycle seems to have closed recently when a large structure on Park Avenue West that had been built for a pharmacy chain became the new home of a Community church. (Richland County chapter, Ohio Genealogical Society collection.)

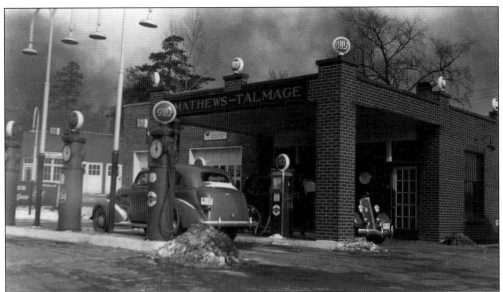

These two gas pumps show different eras in the story of filling stations in town; the one pictured above was on North Mulberry Street and the one at right was on Orange Street. The best illustration of the story, however, is found in the city directories listing all the stations in Mansfield: in 1922, there were 9 of them; in 1936, there were 69. By 1975, Mansfield peaked at 76 stations in town, and by 1990, that number had dropped to 44. Today one will find 29 listed. (Above, Phil Stoodt collection; right, author's collection.)

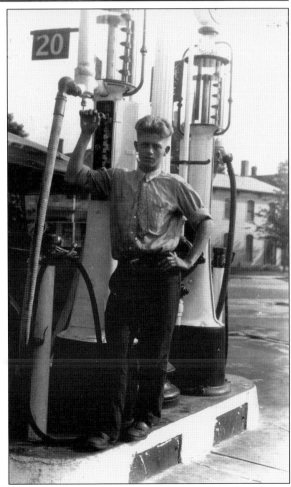

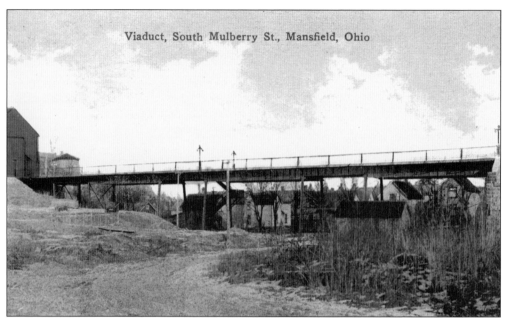

Viaduct, South Mulberry St., Mansfield, Ohio

The first "flats" area of town was not in the north end where people associate the term today but in the south end where the landscape dropped away from the heights at St. Peters to a hollow separating First Street from Glessner Avenue. One of the modern marvels to folks of the young 20th century was this viaduct spanning South Mulberry Street's expanse of flats in order to keep pedestrians and vehicles above the poor folk. In the 1960s, earth embankments were raised beneath the viaduct to create the causeway/bridge it is today. (Phil Stoodt collection.)

The proliferation of automobiles necessitated certain infrastructural changes in the city streets that today might seem commonplace but at that time were radical departures like digging a new route underneath a railroad crossing. This underpass on Park Avenue East was such a revolution in the landscape that everyone in town took pictures of it and one artist painted it. (Marge Graham collection.)

96

Seven

GETTING AN EDUCATION

At least four generations of young Mansfielders associated their grade school memories with massive stone-lined school buildings. There were 10 of these built throughout the city in the 1880s–1890s, similar in architectural style, each an edifice symbolic of the solid virtue of an educated community. (Phil Stoodt collection.)

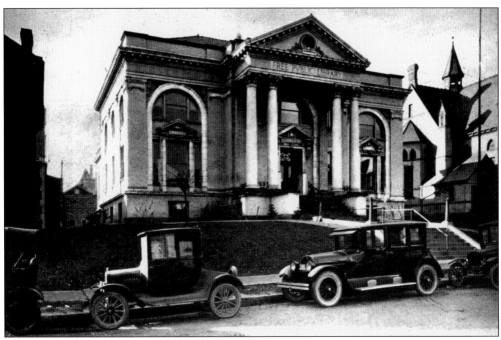

The Mansfield/Richland County Public Library is 100 years younger than Mansfield, having opened in 1908 during the city's centennial year, but its story goes back to 1887 when a group of three women in town formed the Mansfield Memorial Library Association, and in collaboration with a local veterans group built the first library on Park Avenue. It was so popular that within a few years a grant was secured to give Mansfield its own Carnegie library, designed in the classical revival style of architecture to reflect its civic responsibility. (Mansfield/Richland County Public Library collection.)

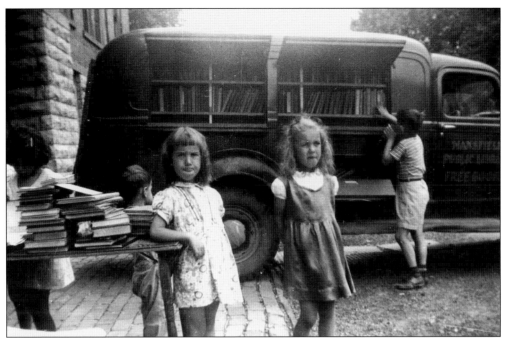

In 1914, "suburban" branches of the library were established in Mansfield at two fire stations, two school buildings, and the YWCA, but in 1931, the library's outreach entered a new dimension with the first bookmobile, carrying the library services right out into the neighborhoods at schools and shopping centers. The bookmobile pictured above was a 1937 Dodge, and the photograph below shows the bookmobile in its 1960s incarnation. The establishment of the library's branch locations put an end to the need for bookmobiles, but they are emblematic of the library's commitment to vigilance in finding ways to meet the needs of the community. (Mansfield/Richland County Public Library collection.)

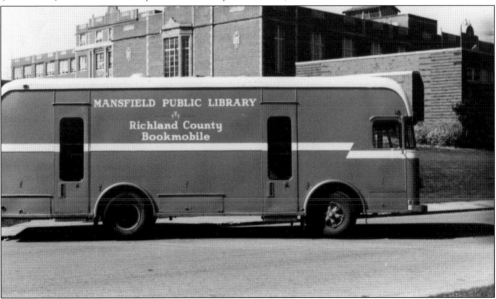

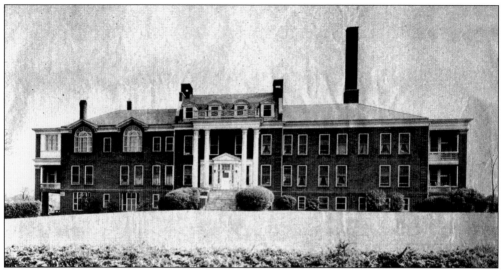

The MedCentral College of Nursing had its origins back in 1908 at the Mansfield Emergency Hospital on Third Street in a small manual of information it published that included a page of 10 rules for nurses. Determining that nurses needed to have better instruction the board established a nurses' training school in 1919 when the new Mansfield General Hospital was built on Glessner Avenue, pictured above, and a few years later when the nurses home was built next door as a dormitory, the school of nursing offered a three-year program with a first-year tuition of $25 (payable upon registration). After decades of expansions when the hospital became MedCentral Health System, the school graduated to a new level in 1997 to become a college of nursing. (Above, Richland County chapter, Ohio Genealogical Society collection; below, Phil Stoodt collection.)

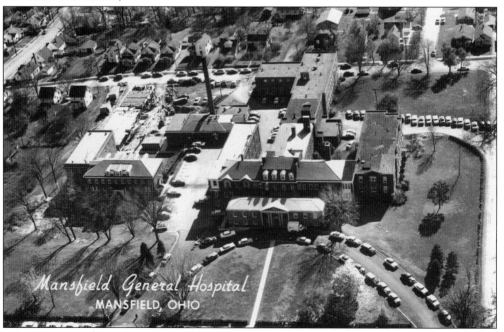

Mansfield's first college was known as the Female Institute, established in the 1840s on West Market Street where the Renaissance Theater is today. Then the Mansfield Business College flourished on the square for a few decades, but it was not until 1958 that the city was designated as the site for a regional campus of the Ohio State University. Through local fund-raising, the 600 acres of forest and meadow were acquired that would become the campus, and in 1966, Ovalwood Hall was built, seen here under construction in the woods. With a commitment to its natural setting, the campus has maintained its wetlands and charming forested glade aura while adding seven more buildings. (Above, author's collection; below, the Ohio State University archives.)

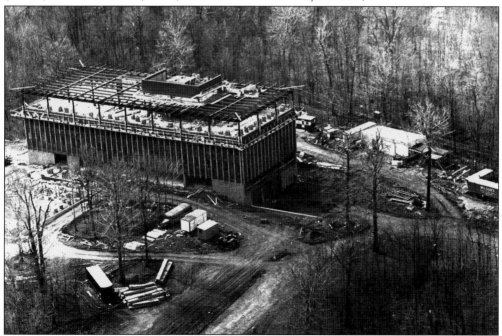

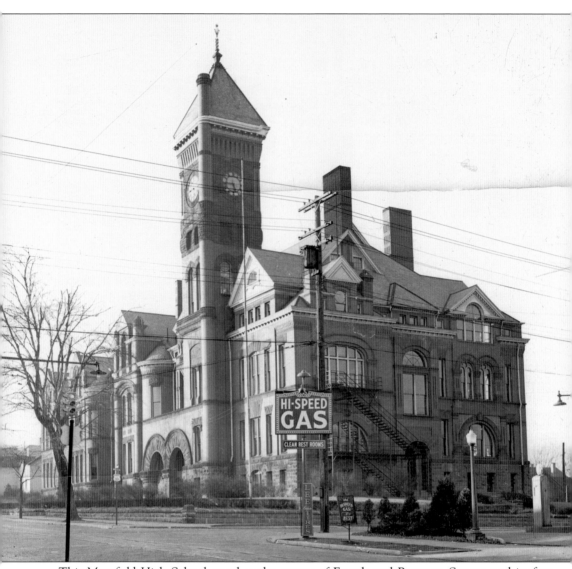

This Mansfield High School stood at the corner of Fourth and Bowman Streets, and its first graduating class of 1892 had 19 students and six teachers. It served only a little more than 20 years before the town's tremendous growth in the second and third decades of the 20th century made it look too small and outdated. This building made way in the 1930s for the construction of John Simpson School, but to this day, remnants of the old site can be seen in the stone walls fronting on the streets. (Richland County chapter, Ohio Genealogical Society collection.)

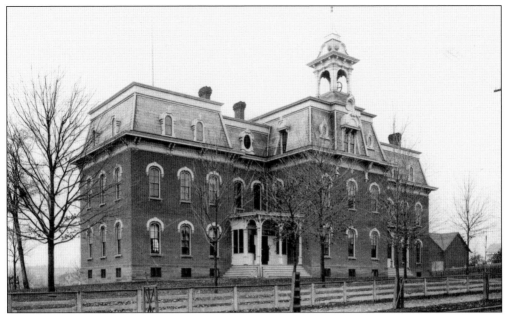

Mansfield's high school began originally in the second floor of a building downtown, but when it got its own first hallowed halls they were in this schoolhouse on First Street. Classes were held here from 1870 to 1892, and then the building became an elementary school named for a Mansfield High School graduate, author Frank Carpenter. (Mansfield/Richland County Public Library collection.)

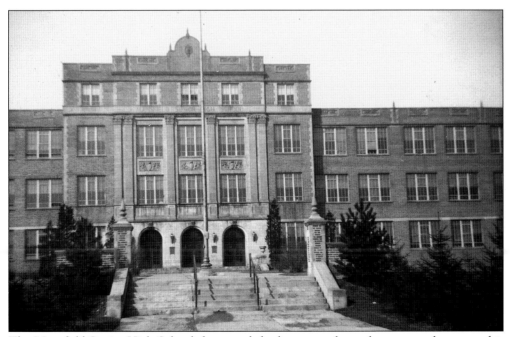

The Mansfield Senior High School that stood the longest and saw the most students was this one on Parkwood Boulevard that opened in 1927. Through the 75 years of its life more than 25,740 young men and women grew up here. (Phil Stoodt collection.)

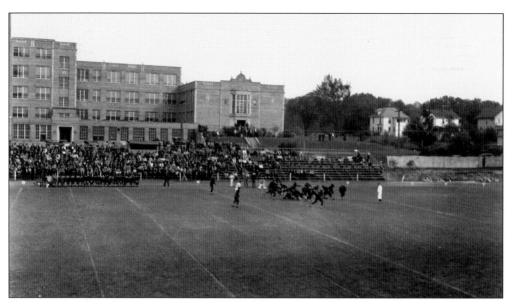

Through a supposed literary nod to William Blake, whose classic English poem that begins "Tyger Tyger, burning bright" made the classic Old English misspelling of the word, the Mansfield mascot was distinguished from its archrival Massillon Tigers spelled as Americans do with an *i*. This photograph shows the Tygers at work on their gridiron behind Mansfield Senior High School. (Maxine Smith collection.)

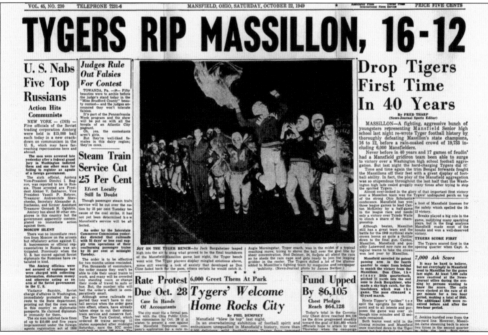

The consummate moment in Mansfield sports history was on October 22, 1949, when the Tygers beat Massillon in football. Throughout the many decades of this rivalry it only happened once. If this newspaper front page was reproduced in color, it would be obvious how important this event was, as these headlines were printed in red ink. The only other time that ever happened was the day World War II ended. (Jack Bargaheiser collection.)

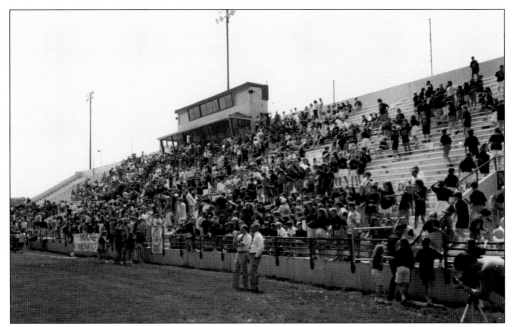

The Tygers took the field for home games in several different locations throughout their many team incarnations. Home games were hosted at the fairgrounds on Springmill Street, at Davey Field across Fourth Street, or, before the creation of Arlin Field, on the turf behind the school. Arlin Field, seen here, opened in 1947 to seat 12,000. (Mansfield/Richland County Public Library collection.)

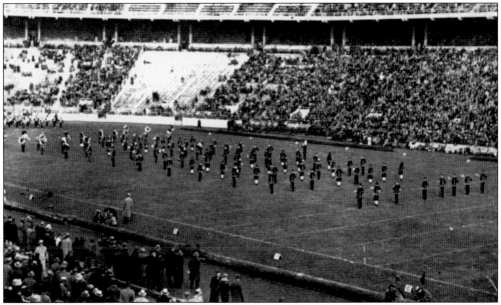

The Mansfield Senior High School band first organized in 1922 with 30 musicians as a pioneer in the sports entertainment field, and by 1950, it had over 100 members including majorettes. In 1941, the Tyger band substituted for the University of Wisconsin musicians in the Ohio State–Wisconsin game and became the first high school band in history to march in Ohio Stadium. (Jack Bargaheiser collection.)

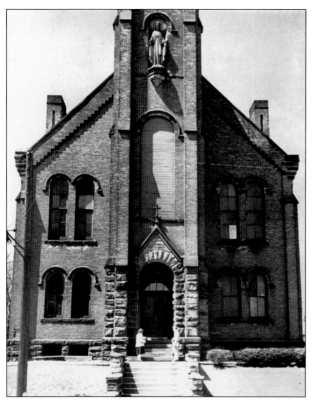

The photograph below shows a large parking lot on the right, and that is where the church pictured at left stood for 70 years as St. Peters High School. The church was built in 1889 to include the school, and when the sanctuary moved next door in 1919 to the grand church with towers that are recognized as St. Peters today, the high school expanded in the old building with a library, science laboratory, and auditorium. The big convent and high school seen below was built in 1958 and provided the inspiration the basketball team needed to become state champions in 1968 and 1978. (Mansfield/Richland County Public Library collection.)

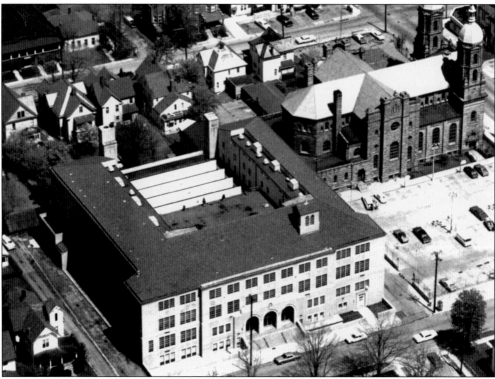

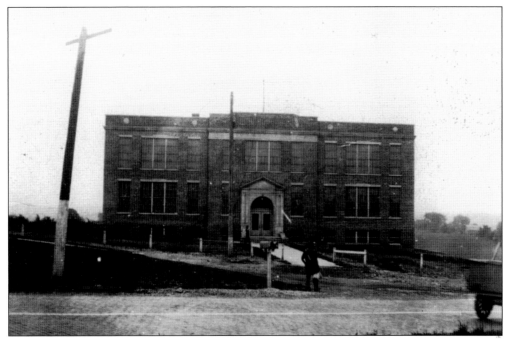

Madison High School started out in this building at the bottom of Ashland Hill in 1925. One might recognize it as Madison Junior High today if one can imagine all the wings added in the 1950s, each of which was larger than this original schoolhouse. (Bob Carter collection.)

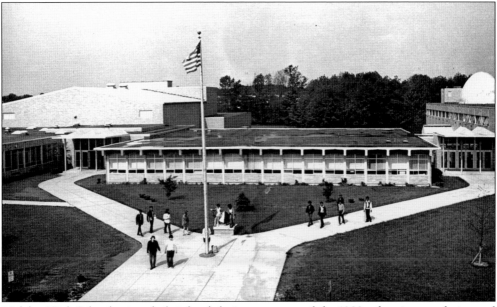

Malabar High School enjoyed a brief and glorious career until the 1980s when it was redesignated as a middle school. If one looks closely in the center of this photograph, one will see that the school bell tells a story of the 1960s when racial tensions found expression in the nighttime painting of the bell—first black then white, then black then white, until an accord was finally reached and the school's emblem came out evenly split right down the middle. (Joyce Oyler Wells collection.)

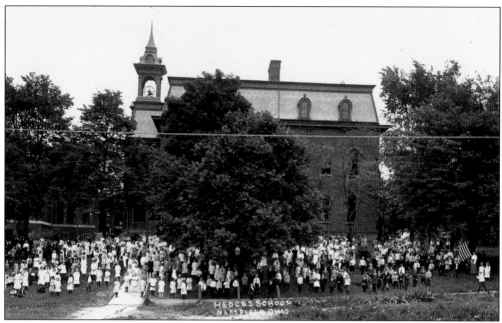

Of all the big old elementary schools built in the 1800s, only one still remains to this day—Hedges School. Opened in 1871, the school has survived through so many additions and remodelings that the whole outside of the place is different, and none of the original parts seen in this photograph are visible anymore. The curriculum has changed, the districting has changed, the societal values have changed, and the only thing constant is the teachers' commitment to children. (Maxine Smith collection.)

The Mansfield city schools go through a restructuring every generation in response to the fluctuating student population and community needs, often enough with major modifications and never without controversy. Following World War II, when the baby boom was taxing the school system's resources, a new wave of elementary schools was built that all looked like Ranchwood School, with a 1950s architecture that was light, airy, optimistic, and totally without regard for energy efficiency. The last of these closed in 2007. (Anita Meyers Hickinbotham collection.)

Johnny Appleseed Junior High School opened on Cline Avenue in 1940 to accommodate growth in the south end of Mansfield. Even in the hard times of the 1930s, voters approved a bond issue, and with the assistance of federal funds, there were two new schools built at that time: Appleseed and John Simpson Junior High on Fourth Street. A student handbook issued to young Appleseed Pioneers in the 1940s addressed respect for school property saying, "Care must be taken that walls, floors . . . are not disfigured in any way," which, of course, did not apply to adults because the school was demolished in 2005. (JoAnn Brucato Barlow collection.)

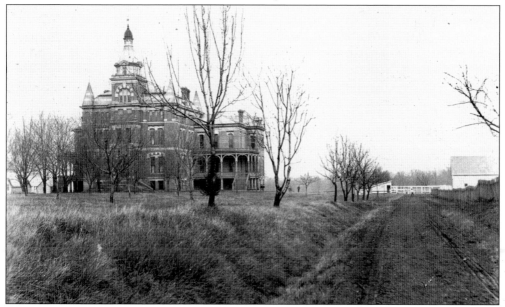

The children's home was on Home Avenue, and to see this site today, filled with buildings, one would never guess that it was once such an expansive place. Built in 1882 when Hedges Street was the edge of town, the children's home was way out in the country. Never lacking for parents of all sorts, the orphans received special attentions back then, including free passage on streetcars and admittance to Casino Park. (Mark Hertzler collection.)

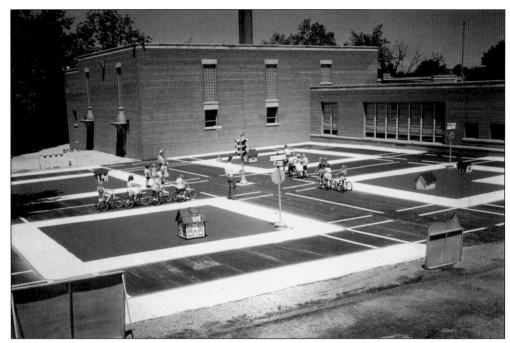

Everyone who has ever been to Safety Town, no matter where in the United States that may have been, has taken part in Mansfield's history, because it started here. The first Safety Town in America was held at Prospect Park in 1937 with 40 kids driving little peddle cars and learning to cross the street. Those little houses and stores were built and wooden sidewalks laid out there, but by 1953, it was felt that the park was too dusty and gravelly for a school that was already famous and spreading around the state, so a blacktop was paved at Brinkerhoff School and a sign was posted there at the new city limits of Safety Town, Ohio. (Above, Mansfield/Richland County Public Library collection; below, Linda Chevalier collection.)

Eight

MAKING MONEY

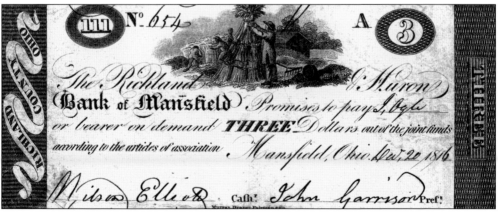

John Garrison, who signed this bill as president of the bank, came to Mansfield in 1812 to help build the blockhouse in defense of the town. In 1816, he and other businessmen organized the Richland and Huron Bank of Mansfield and issued bills on the frontier in denominations of $1, $3, $5, and $10 even though there were fewer than 600 people in town at the time. This bank and others in Ohio all collapsed within a few years. (Mark Hertzler collection.)

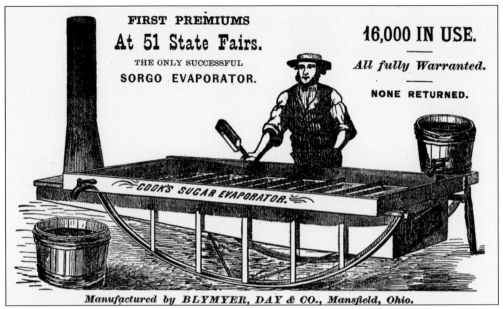

Most of the sugar in the United States came from the South, so when the Civil War cut off that supply everyone needed a Cook's Sugar Evaporator to make maple syrup. Invented by Daniel McFarland Cook, who lived on Cook Road in Mansfield, the large, shallow boiling pan became the standard means of production, making Cook a fortune. (Author's collection.)

The company that manufactured the Cook's Sugar Evaporator was Blymyer and Day, whose factory complex on North Diamond Street was the first large manufactory in town and progenitor of all Mansfield's industrial success both figuratively and literally, as the industrial buildings that it created later passed to two Mansfield giants: first the Aultman-Taylor Company and then the Ohio Brass Company. (Author's collection.)

Daniel McFarland Cook sank his entire fortune into his experiments, acquiring a number of patents from 1860 to 1898 and inventing a lightbulb seven years before Thomas Edison. He died a poor man in a borrowed house, however, and had been known as "Crazy Cook" for 30 years because of the object photographed below and this newspaper article that appeared in the *Mansfield Herald* in 1859, and subsequently in newspapers all over the country, under the heading "Flying Machine." One can assume that it never flew because nothing more was ever said about it, and it served as a chicken coop for some number of years and was known to make an excellent smokehouse. (Author's collection.)

the completion of an electro-motive engine, which is not alone designed for the navigation of the air, but for every conceivable purpose in the mechanical and agricultural departments. For this engine I have applied for a patent, but it not having been issued as yet, for obvious reasons I withhold a description of it.

I am now engaged in the construction of a house to carry on and complete my great design—the air-ship—and hope, by the spring of 1860, to have my favorite model aerial car, "Queen of the Air," perfected. By this invention I expect to navigate the air at will with an inconceivable velocity. The car will be 12 feet long and 4½ feet in its equatorial diameter, and of a true, pointed ellipse; and will be elevated, propelled and directed solely by the force of the electric engine, without hydrogen gas, steam, fans, or rudders.

I confidently expect to finish my experiments during the coming winter; and next summer, if successful, will make a voyage to San Francisco, *breakfasting here, dining there, and returning the same day for supper, making the entire trip in about twelve hours!*

Such is the kind of motor agency which has occupied my attention. As to its feasibility I will leave the world to judge for itself when this statement shall have been practically demonstrated. Respectfully,
 D. M. Coox.

The H. L. Bowers Company made the best 5¢ cigars in town called the Bill Williams and sold them with a label that showed a billy goat. Playing on the words Bill and William, it advertised "100 Bills for a $5 Bill" and sponsored promotional events where anyone named Bill or William was an honored guest. Every year there was a Bill Williams Day at Casino Park where all the Bills posed with the company mascot, and in this photograph, they all parade around in 1908 behind their goat before a big bash on the square. Mansfield had a reputation as a big cigar and beer town at that time, with 16 cigar factories and 54 saloons. When Carry Nation, the famous hatchet-wielding temperance activist, made a stop here once to make a speech in the square and sell souvenirs, she decried that "the city of Mansfield is built by liquor traffic." At the Baltimore and Ohio depot when she left her bags unattended for a moment, officer Bell and his friends hid a large beer bottle in her bag to be discovered when she put up for the night in Mount Vernon. (Phil Stoodt collection.)

The American Cigar Company, at the corner of Fifth and Adams Streets, was the largest cigar manufacturer in town. It marketed a dozen different brands of cigars and all of them were hand-rolled, so with such a labor-intensive, unskilled operation it employed men, women, and children. Although Congress had considered child labor laws as early as 1904, none were enacted until 1938, so a major obstacle to education in town from 1900 to 1920 was kids skipping school to make cigars. (Above, Phil Stoodt collection; below, Jeff Wahl collection.)

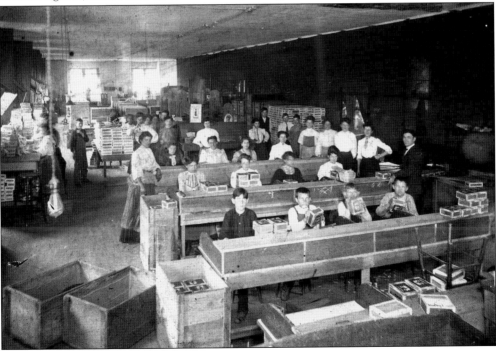

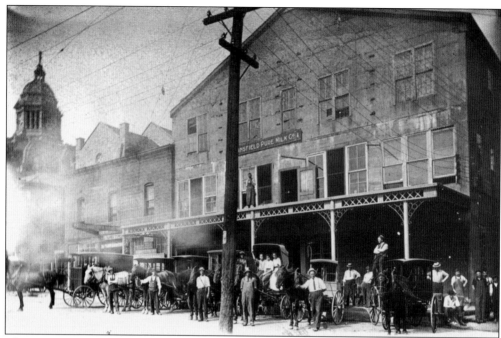

The Mansfield Pure Milk Company on Franklin Street, opened in 1902, was a high-volume dairy distributor with 26 delivery routes owned by a family named Isaly. Within a few decades, the Isaly name was known all over the state for dairy plants and ice-cream stores, and by 1950, there were a dozen plants and 400 stores in the Isaly chain. There were a dozen different Isaly's in Mansfield through the years, ranging from ice-cream stands to diners, including this one on the corner of Fourth and Mulberry Streets. Isaly's enduring legacy, now that the stores are gone, is an ice-cream product it developed in the 1920s—the Klondike Bar. These images appeared in *Klondikes, Chipped Ham and Skyscraper Cones* by Brian Butko.

Of the many breweries in Mansfield, the last one standing was the Renner-Weber Brewery on East Fourth Street. Begun in 1884 by Henry Weber, a German immigrant whose family had a brewery in Baden, the brewery had no refrigeration for years and could only make beer during the cool months. The brewery complex had underground caverns of brick for storing so much beer that when they were designated for air raid shelters in World War II it was judged they could hold 900 people. (Eileen Wolford photograph.)

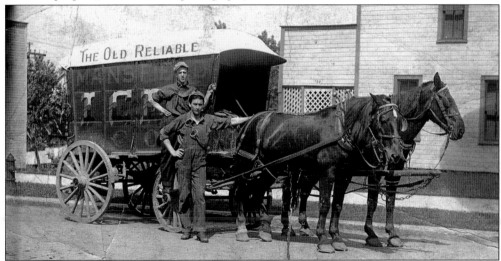

Neither the dairy industry nor the beer industry in Mansfield could have survived without the ice industry. The Mansfield Ice Company seen here was only one of several ice distributors in town. It harvested its ice from the Black Fork River, from several millponds north of town, and from lakes ponded by dams placed in Touby's Run every year before the winter freeze. The ice was stored in large insulated barns, including a huge farm building that was eventually modified to become the Casino at North Lake. (Adelia Van Geem Hautzenroeder collection.)

In today's media-saturated world it is difficult to imagine what a profound impact the radio made on American society back in the 1930s. The story of radio in Mansfield can be told through the interrelationship of these four photographs: Denny Skelton, the town's first certified radio repairman, hurried down to the railroad station with his daughter Jeannine, seen here, on his shoulders so she could see the president, because he had heard on the radio that Franklin Delano Roosevelt would make a quick stop in Mansfield. This photograph of Roosevelt, whose pioneering radio legacy established precedent for national media ever since, shows him in front of a radio microphone with the call letters WJW, which was Mansfield's own radio station. (Left, author's collection; below, Richland County chapter, Ohio Genealogical Society collection.)

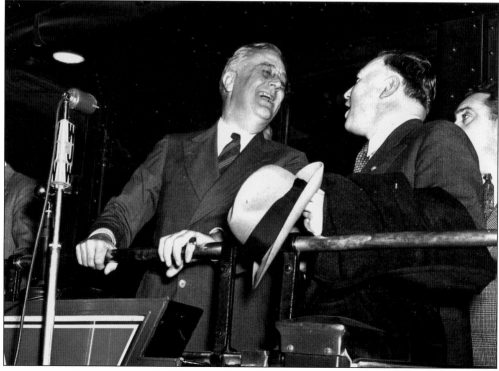

WJW started broadcasting from the top of the Richland Trust building as soon as it opened in 1929. Founded by John Weimer, whose initials provided the WJW call letters, the station broadcast at 1210 kilocycles. This photograph of the radio crystal equipment was taken in the ninth-floor penthouse where the *Richland Trust Hour* originated every Friday night featuring singers, pianists, celebrity announcers like Harold Arlin, and even the Reformatory Band and the first Miss America in 1930. WJW left Mansfield and went to Akron and then Cleveland, where it still exists today as WJW Channel 8 Television. Its successor in town, WMAN, started in 1939, its studios are photographed here (below) on Park Avenue. (Danja Kindinger Thompson collection.)

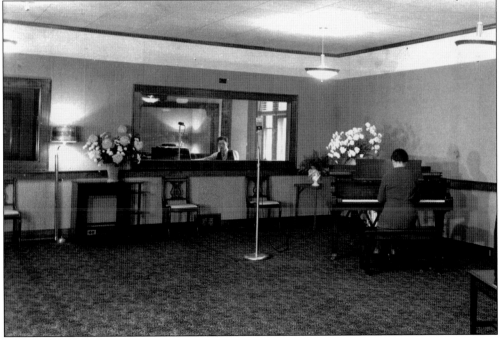

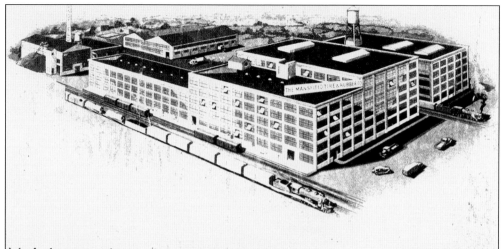

Made by more than a thousand Mansfield men and women—sold by leading merchants everywhere.

MANSFIELD TIRES

When the Mansfield Tire and Rubber Company started in 1912, there were so few automobiles that the law required a driver to stop his car to allow the horse and buggy to pass. Within the next 50 years, the company grew to proportions such that they made tires not only here but also in California, Mississippi, and Canada, their customers including Sears, Montgomery Ward, and Amoco. The Mansfield name was on streets and highways all over America whether the drivers knew it or not. There was an unconscious sort of pride that people here took for granted seeing Mansfield written large on billboards and filling stations, even if it was advertising tires, and when the plant closed in 1977 the town lost far more than jobs. (Above, Richland County chapter, Ohio Genealogical Society collection; below, Mansfield/Richland County Public Library collection.)

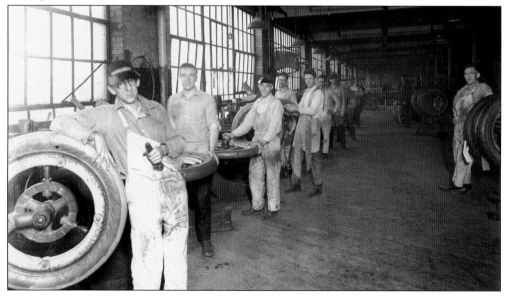

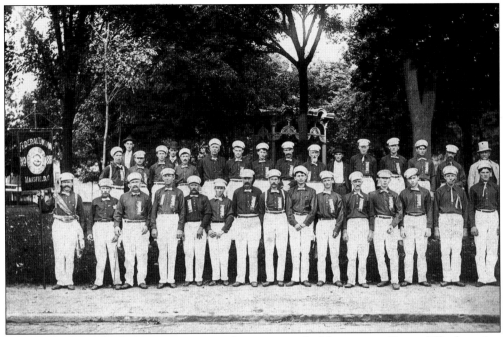

Mansfield always had the reputation as being a tough labor town. From difficult union negotiations as early as the 1920s, when this photograph was taken on the square, and more severe work stoppages in the 1940s and 1950s, scars were hardened that never really healed in those generations. There were men on the assembly line at Westinghouse in 1972 who had not spoken to each other since the strike of 1956; even though they stood a few feet apart, intermediaries had to conduct the communications between them. Accompanying the changes in Mansfield's industrial makeup over the last 20 years of the workforce, the union presence has declined, perhaps most visibly in the length and scope of the Labor Day parade as opposed to when this picture was taken in the 1950s. (Above, Richland County chapter, Ohio Genealogical Society collection; below, Mansfield/Richland County Public Library collection.)

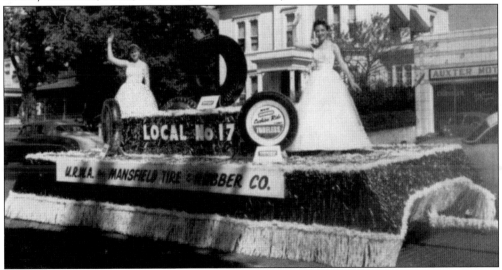

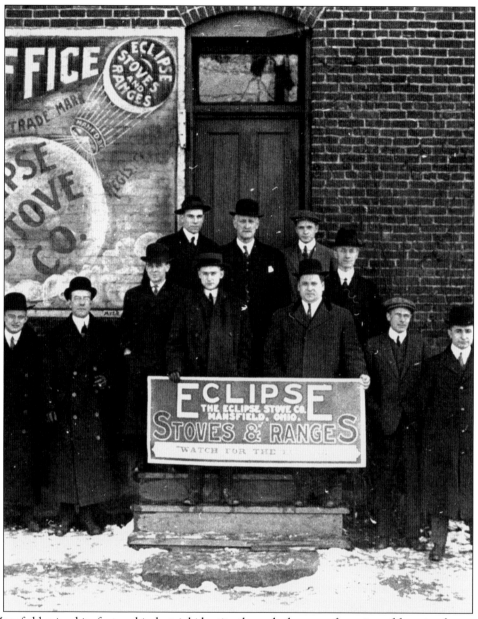

Mansfield gained its first real industrial identity through the manufacturing of farm implements in the early days of the Industrial Revolution, but during the decades from the 1890s through World War II and even after, Mansfield was the place that made stoves. Although Tappan and Westinghouse sold electric ranges in later years, the stove business here started with the big old potbellied iron heating stoves and flat-topped wood- and coal-burning kitchen ranges made by the Baxter Stove Company and the Monarch Stove Company. The Eclipse Stove Company, photographed here, opened in 1889 but agreed to change its name to end confusion with another company of the same name, so in 1920, it became the Tappan Stove Company. Of all those many thousands of massive stoves made in Mansfield, practically none are found today, all gone to the scrap pile in the 1940s to make materials for World War II. No doubt there are bits of Mansfield stoves in the fields of Europe and the waters of the Pacific. (Tom Tappan collection.)

Although there is virtually nothing left of the Ohio Brass Company today except an office building too nice to tear down that carries its name as a memorial, although the products it manufactured have been made obsolete enough (through the evolution of technology) to virtually drop from the vocabulary of the 21st century, and although most of its players in the game, from the pawns right up to the king, have long ago left the board, Ohio Brass remains to this day. It is seen in the streets and waterlines and sewers built with the revenue generated from the company and its employees; in the neighborhoods and homes built from 1888 to 1990 by people who earned their living at the company; in Kingwood Center, built by a man who built the company; in the city's hospital, launched from the civic generosity of Frank Black, who founded Ohio Brass; and in the Discovery School and the Mansfield Art Center that came from his family after he was gone. In so many ways the Ohio Brass Company, although it is long gone, is still a living vibrant pulse in the town. (Todd Boebel photograph.)

During the 1940s, everybody went to war whether or not they shipped overseas. At Westinghouse there were 7,500 Mansfielders engaged in the war by manufacturing an array of war production materials ranging from field binoculars to shell casings. The photograph at left, taken in 1944, shows how the refrigerator assembly line converted to making tail cones for the P-47 Thunderbolt, the U.S. Army Air Corps fighter plane. The crowd pictured below gathered at the Westinghouse Mansfield Works in 1943 to witness the presentation of an Army-Navy E flag (E for "excellence") to the War Production Council. (Lewis Stambaugh collection.)

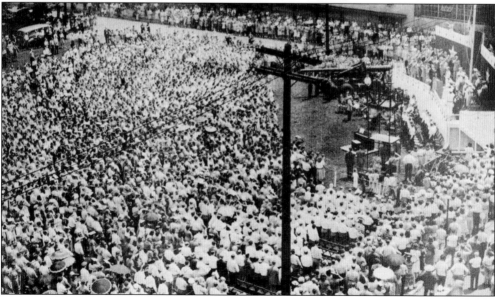

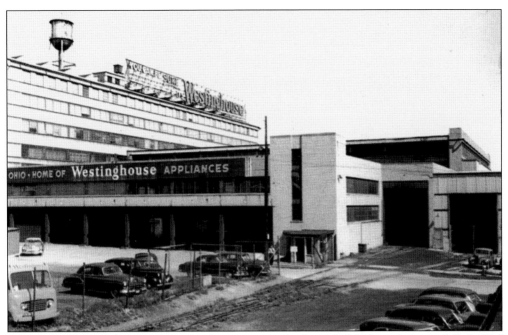

Westinghouse was a huge presence in the city, not only through 8,000 employees—fully half of Mansfield's workforce at its peak in the late 1940s—whose lives were all intimately invested in the company's fates and fortunes and through the physical presence of the behemoth industrial complex of glass and brick and steel that pulsed and hummed right in the side of downtown but also in the minds and imaginations of anyone who came down Ashland Hill at night or rode on the train after dark, because one could not miss that huge animated yellow, red, and blue light in the sky that said Westinghouse. (Mansfield/Richland County Public Library collection.)

Of all the dozen major industrial powers fueling Mansfield that started before World War I, only one is still vital and thriving today—the steel mill. Photographed here in 1926 when it was still the Mansfield Sheet and Tin Plate Company, it was shortly to become Empire Steel. When the State of Ohio lists its assets in steel towns, Mansfield is always near the top along with Youngstown, Akron/Canton, Portsmouth, Niles, Lima, Springfield, and Massillon. Depending on which generation one speaks with, whether the place was known as Empire-Detroit, Cyclops, Armco, or AK Steel and whether it was going through shutdowns or expansions in good times or bad, the employees at the steel mill of every decade have always played a role in pushing the United Way up to or over its goal. (Above, Anna Marie Nelson McCracken collection; below, Jeff Sprang photograph.)

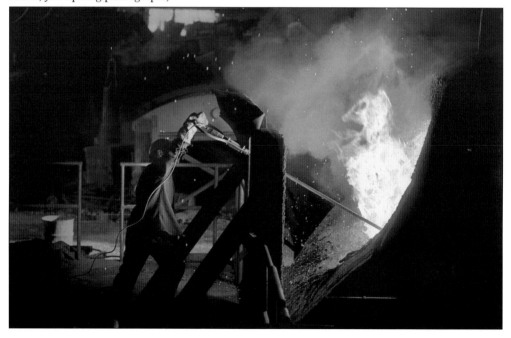

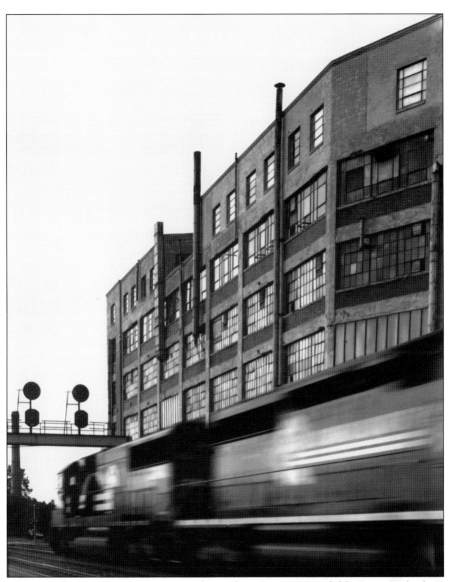

When Westinghouse closed in 1990, after Ohio Brass, Mansfield Tire, Peabody-Barnes, Humphreyes, Dominion Electric, Tappan, and so many others, it looked as if Mansfield had died, and with it the promise that had been so steadily strengthening through the last century. Having nothing to base any hope on at the time, because big industry was clearly faltering everywhere, it appeared as if the train was passing Mansfield by. Who could have foreseen at that time that the economy of the United States was refitting for a new paradigm of predominantly small manufacturing and service industries and that Mansfield would actually pioneer that course and be recognized as a model to the rest of the country. Now instead of a few big companies employing a lot of people, there are hundreds of smaller companies employing a few dozen. Now instead of smoke and brick and glass in the flats, there are modest plain buildings with lawns and trees in the industrial corridor by the airport. Mansfield is vital and healthy again with the vigor to grow, and while the past is an essential element of its identity, the living Mansfield is happening right now. So it is time to close this book of history and go be part of today. (Todd Boebel photograph.)

www.arcadiapublishing.com

Discover books about the town where you grew up, the cities where your friends and families live, the town where your parents met, or even that retirement spot you've been dreaming about. Our Web site provides history lovers with exclusive deals, advanced notification about new titles, e-mail alerts of author events, and much more.

MADE IN THE USA

Arcadia Publishing, the leading local history publisher in the United States, is committed to making history accessible and meaningful through publishing books that celebrate and preserve the heritage of America's people and places. Consistent with our mission to preserve history on a local level, this book was printed in South Carolina on American-made paper and manufactured entirely in the United States.

This book carries the accredited Forest Stewardship Council (FSC) label and is printed on 100 percent FSC-certified paper. Products carrying the FSC label are independently certified to assure consumers that they come from forests that are managed to meet the social, economic, and ecological needs of present and future generations.

FSC
Mixed Sources
Product group from well-managed forests and other controlled sources

Cert no. SW-COC-001530
www.fsc.org
© 1996 Forest Stewardship Council

Find Your Place in History.